Family Photographs

Family Photographs

CONTENT, MEANING, AND EFFECT

Julia Hirsch

New York Oxford
OXFORD UNIVERSITY PRESS
1981

Library of Congress Cataloging in Publication Data
Hirsch, Julia.
Family photographs.

1. Photography of families. I. Title.
TR681.F28H57 778.9′26 80-25591
ISBN 0-19-502889-9

Printing (last digit): 9 8 7 6 5 4 3 2 1

Printed in the United States of America

In memory of
Menco Max Hirsch
and
Sophia Prins-Lunzer

Preface

One day several winters ago I asked myself, "What do family photographs tell us?" The question was deliberate. I had decided to discuss it with some colleagues with whom I was exploring the place of the visual image in the history of ideas.

The question was intensely personal to me. I had first learned about life and death from a particular photograph which disturbed me as a child. The photograph was a formal one my father had taken of my mother and her family: six brothers, two sisters, and their aging parents. It frightened me then because I knew that four of the people were dead and yet a paper image kept them alive. At the same time, the way my mother looked annoyed me: stolid and grim, not the affectionate and playful person in whose lap I loved to sit. I liked her the way I knew her and resented her for once having been different in a time and place unknown to me.

Since photography and family had been so vividly allied in my own experience, their association seemed obvious. But as I prepared the remarks I was going to make to my colleagues, I found myself quite alone with nothing to refer to. The major work on the history of the family in art is essen-

tially about the history of childhood. I could learn about the technical development of photography; about its use by painters; about the photographs of a few particular families; about the clues that photographs provide of furnishings and styles of clothing; about their use in psychotherapy; about their dating and storage. But nowhere could I find out what family photographs show, at what times people take them, how they look at them, why they hold on to them or throw them away. Nor could I find out what difference the camera has made to our image of the family. I looked at a great many photographs—my own, my friends', famous ones in museums, obsure ones in archives, discarded ones in garage sales—and tried to discover in them what themes lie beyond the stories we tell when we speak about our own family photographs.

To the friends who generously supplied me with photographs I express the hope that I treated their relatives with the same discretion I extended to the total strangers I found in photographic archives and museums. To my friends' pictured kin I have the debt I owe to the photograph that troubled me as a young child: they were my source and my inspiration. I hope that I have given all these faces, all these persons, all these lives their due respect.

New Jersey J.H.
September 1980

Acknowledgments

This book began as some conversations with Robert Knoll and Nancy Macauley, whom I met, under the auspices of the National Endowment for the Humanities, at the National Humanities Institute in New Haven, Connecticut. Many other persons have guided this work. I would especially like to thank James Raimes for helping me begin writing; Tony Outhwaite for helping me finish; and Herbert Schwartz, Katherine Ebel, and Elizabeth Schwartz for their encouragement along the way.

Contents

Family Photographs

1

Family Photographs

A PERSON WHOSE PHOTOGRAPH decorates a desk, a wall, a wallet, a gravestone, may command family devotion. But we cannot be sure that his photograph is a family photograph because it does not itself show a blood tie.

A family photograph contains at least two people, though it may contain a score. Physical features are an essential clue to kinship: noses, eyes, and foreheads, like those of the siblings on page 4 (1.1 and 2), tell us what ties link these faces to each other. And yet the most haunting aspect of the photographs is not the likenesses between these siblings but the evocations of the images themselves. We wonder as we look at these young faces about the closeness and separateness, about the dependency and rivalry, the love and ambivalence which strike all family relations. What of all this did these children already know? How did their temperaments sit with the inheritance of features that they shared? And what did they become when they grew up? The photographers who portrayed them needed no special effort to show their ties because the physical resemblances are clear enough. But often, in family photographs, they are less conspicuous and photographers

3

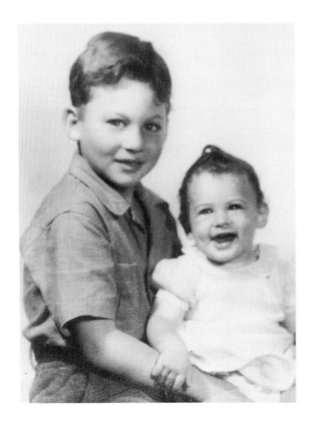

1.1 Brother and sister, 1940s
(Author's collection)

1.2 Sisters, 1930s
(Courtesy of Carole E. Schwartz)

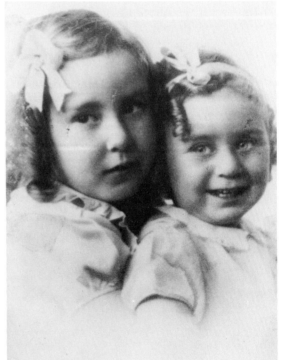

have relatives tilt their heads, or look at each other, in order to suggest their relationships. If we do not know the individuals portrayed we put all our trust into such gestures: a woman and the cradled infant in her arms are mother and child; a man standing and leaning slightly over the woman seated next to him—husband and wife.

Family photographs identify themselves both by internal and external clues. The two sets of siblings show us how internal clues work; they would be fair game for a geneticist who could discover here the curious tracings of inherited features. External clues are more diffuse and even more capricious, depending for their form, richness, and accuracy on the skills of a narrator whose reliability we may have no reason to trust. The caption on the back of a picture, or in an album, may simply read, "Mom and Dad, Brighton, August 1893," and offer us only a record of time and place. A personal, oral account usually has more texture and complexity, reaching far beyond the scope of the picture itself. "That's Aunt Sadie and Uncle George," a loving niece might say. "She made the best oatmeal cookies you'd ever want to eat. And he just loved fishing." Their prodigal son, viewing the same shot, might speak of a doting mother and a tyrannical father, while we, merely viewing the image, would see only the woman's demure smile and the man's steady gaze as they confronted the photographer. Family photographs themselves do not change, only the stories we tell about them do.

When we know that a particular photograph is that of a family member we can easily fit it into whatever fabric of family experience time has already woven. It acts as a new thread in an old weave. But often we come across photographs

5

showing groups of people of whom we know nothing: neither their histories, nor their place in someone's biography. Archives, museums, picture collections, even antique stores, are full of such ancestors who have lost their descendants, and we enjoy meeting them—even collecting them and hanging them up in our homes as "period" pieces—because beyond their particularities, they also show a larger order of human history, the condition of being part of a family, a social unit bound by blood, custom, duty, money, and passion. Other groups are just as photogenic and offer more conspicuous signs of their community. We can recognize the American sailors, for instance, by their uniforms (1.3). In family photographs, the visible signs—the physical resemblances, the gestures, sometimes the places—can also tell us when and where pictures were taken, and so provide us with all kinds of information about families' lives and times.

But family photography is also provoking. It invites our curiosity about personalities and relationships but cannot fully satisfy it. If we do not know the individuals—if we happen to see them on the walls of a friend's house, on the desk of a colleague whose office we share, in a library book, or in a motel night table—we are easily attracted by a human constellation whose names and voices we ignore. The picture, with its display of eyes and hands, perhaps even bosoms, groins, and legs, seems to bring intimacy without any formal introductions. But this is a superficial closeness. We have no more than a set of poses, of textures, to go on, and we recognize, finally, that the picture, like the faces we see on the television screen when the sound has been turned off, tells us only the barest of narratives. And yet for all its limitations,

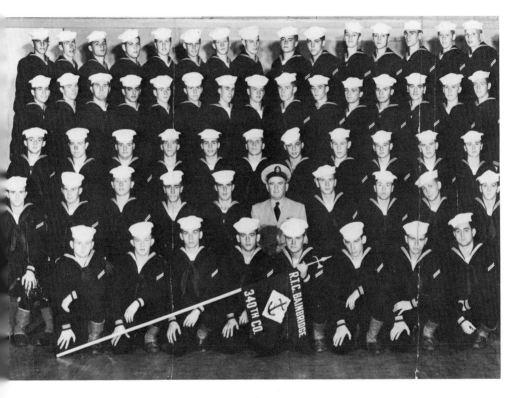

1.3 Bootcamp, United States Navy, 1950s
(Author's collection)

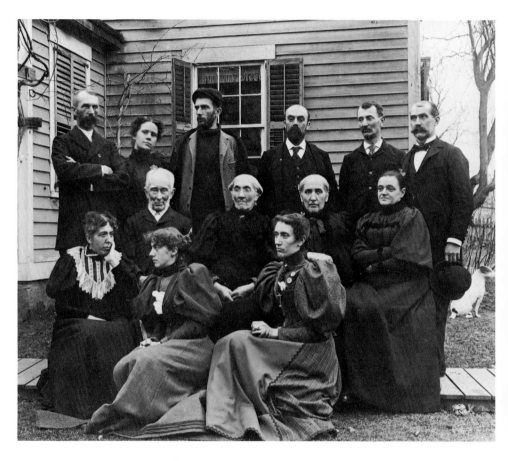

1.4 A family in Seymour, Connecticut;
photographed by the Rev. Hollis A. Campbell in 1893
(New Haven Colony Historical Society)

it can be a narrative of great intensity. Even though we know little about the Campbell photograph (1.4), we have no trouble reading it as an allegory of repressed conflict between the bearded young man at the back and the assortment of angular Yankee faces all around him. It is not so much what we can see of the group but what we know of the human condition that makes this a striking family photograph.

The family photographs of our own kin, and of our friends, have quite the opposite effect. We see them as segments in an on-going historical and psychological pageant which includes active as well as passive participants: those who took the photograph, those who had it taken, those who kept it, and those who look at it. But each person has his own motives and circumstances. The person taking the photograph defined its subject; those photographed took a chance on their own visual immortality; those who look at the picture answer to their own longings and curiosities. All these motives are rooted in a known event. The person who has kept the picture may not have been there at all. For him, reading the photograph becomes an imaginative exercise, in which he may well second-guess reality. "How pretty little girls looked in those days," he might say, ignoring the photographer's efforts to make two ornery children look coy. "How I wish I had known him," he might feel, responding to the portrait of a splendid forebear, unaware of the play of light needed to make a coarse face look sensitive. When we know those pictured, we read their photographs against what we know of their lives, and ours, and scour them for clues to psychic mysteries. "Didn't she look bad before her nose job?" we might say, or "Look at Joey, only three and already crazy about cars," or "That must have been the summer before

9

their divorce." Our own family photographs delude, obscure, or reveal, but never leave us entirely neutral. They are always relics which remind us of what we had forgotten, make us want to forget what we remember, and bring into relief what we already knew.

Not one of these invocations, of course, is peculiar to family photographs. Letters and diaries also record intensely personal experiences in the imagery and vocabulary of myth, of folklore, and even of art which we all absorb, often unaware, from the culture and society around us. But photography, with its speed and modest cost, offers us distinctive opportunities for the spread of images; and, like the printing press, which spurred literacy by spawning texts upon which to exercise it, photography has generated new habits and new appetites. It allows us to see ourselves in a more permanent form than in Narcissus' pool, or in Snow White's mirror; and it enables us to control the circulation of our faces in ways never dreamed of in the archetypal stories of self-love and self-awareness. Family photography plays a modest part in the history of technology which, in the nineteenth century, found a way of making and preserving images, first on metal and then on paper. But it plays a large part in the history of ideas which first defined the individual, and then the secular family, as artistic subjects.

This history of ideas begins in the Renaissance, that potent age with shadowy edges which started after the Black Death and in some respects extended into the French Revolution; that age that invents the telescope, discovers the vigor of non-European cultures in a New World, and defines the self. The Renaissance cloaks that self in various guises: in the

sonnet, in the novella, in letters and autobiographies, and in the secular portrait which gives new and special prominence to the family. It is also the Renaissance that decides what about that self is worth recording and defines its destiny as conflict between hierarchy and chaos, sham and sincerity, the bee of tradition and the spider of innovation. All of these strains serve to color the individual and the family portrait and also to set the standards by which human images are to be read. The phenomenon we know as the "family photograph" arises in an age which like the Renaissance is intensely curious about the self, its share in history, its place in time, and draws heavily on the Renaissance portrait both for structure and content.

But family photography is more than a translation of one medium into another. It overlays Renaissance conventions with the visual styles of nineteenth-century France, England, Germany, and America. The major feature of this style is the mood which some call the "romantic agony," a sense of longing which speaks so clearly out of the poems of Baudelaire, an early critic of photography, the songs of Tennyson, that most patriarchal of photographic subjects, and family photography itself. And yet when we look closely at nineteenth-century photography and try to pinpoint the sources of its wistfulness we find that it stems as much from the associations we have with particular poses as from any inner states the images actually reveal. A second look at the Campbell photograph (1.4) makes us wonder. Is it really a study in gloom? Or is it only a show of effects—a woman holding her chin and gazing into the distance, a man with folded arms, a young girl's profile with uplifted gaze, an old woman with puckered

mouth and slits under her brows in place of eyes—which art, literature, and psychology have taught us to read as signs of pensiveness, authority, sensitivity, and cunning?

There are no simple answers to these questions because in photography, too, we must navigate between style and content, allusion and ambiguity, intention and actuality. Family historians have learned to read diaries, letters, and autobiographies with care, since unlike demography, these records of personal experiences and feelings are colored, for all their immediacy and vividness, by literary and social conventions. We must look at family photography with similar restraint, for it is created by the aesthetic and social conventions of the people who take them, pose for them, and hold on to them.

The authority of these conventions, like the hold of traditional family roles which still makes us want strong fathers and nurturing mothers, loving children and sheltering homes, is difficult for any of us to resist. Professional as well as amateur photographers still place families in poses that express and cater to these longings. Family photography is an aesthetic, social, and moral product of which the family is at once seller and consumer. It survives and even grows in importance because it suggests age-old patterns both of life and of aspiration. We all follow these whenever we choose which of our family photographs to keep, and which to discard, decisions we make not in the name of "historical accuracy" but for the sake of a standard of meaning that the images either uphold or betray. We do not normally keep photographs that show us disarmed by our children, angry with our spouses, and shamed by our parents. Such glimpses into reality are the stuff of photojournalism: they do not belong with the images we use among our own relatives to buttress family

pride and sustain a sense of security. Nor do we usually hold on to our wedding pictures after the divorce, and to snapshots which show us, tenderly, with a mate we have since shed. Such pictures may be true to our lives but we do not like to preserve evidence that some of our family dreams failed in spite of the effort we brought to them.

This editorial authority is exercised as well whenever we take family photographs. There is always that moment in the present which beckons to immortality, that moment that is not only felt but immediately seen as its own past and secondhand future. "That look I've got to get." "Quick, get the camera." "Shift your veil a little so your eyes will show up." Lumps of experience, rites of passage, grains of poignancy and promise: all of these turn us into artists sorting through life in search of shapes and events which our cameras will turn into symbols and allegories. The sleeping child, the fleshy mother, the tired father, the testy siblings can, in the quick eye of the camera, be transformed into images of innocence, protectiveness, enterprise, and sharing. Family photography is not only an accessory to our deepest longings and regrets; it is also a set of visual rules that shape our experience and our memory.

2

History

FOR A FORMAL PHOTOGRAPHER we fix our hair; for a candid one, mess it a bit. The formal photographer says "Sit up"; the candid one says "Relax." Formal photography is static; candid photography, dramatic. Yet, despite these differences, formal and candid family photography share the same history and use the same fundamental images. The history is the pictorial history of the family; and the images are three ancient metaphors for the family itself. These describe the family as a state whose ties are rooted in property; the family as a spiritual assembly which is based on moral values; and the family as a bond of feeling which stems from instinct and passion. In Western culture—the culture which invented photography —state and spiritual assembly are associated with the father, and feeling with the mother. But the images overlap and the sex roles can be reversed.

The image of the family as a bond of feeling begins as the image of a single parent. It is probably the oldest and is personified in the Semitic Astarte and Tanit, and in the Virgin Mary, all of whom exemplify fertility and nurturance. The mother as the giver of food and caresses, of pets and toys,

is depicted in countless paintings and photographs, and over-shadows by far the equally historical experience of women as mistresses and victims. We see this perennial mother in the 1876 photograph of the London beggar woman holding an infant (2.1) and in the snapshot of the woman in shorts with her baby (2.2). The pretty woman crouching behind her son (2.3) is using him as a foil to her own beauty: he seems to be her plaything rather than the object of her care. But even this photograph shows the edges of the same ancient image. The man cradling a baby as if it were a package of suspicious origin is also a mother *manquée* (2.4). But his awkwardness is amusing and implies no important shortcomings just because he is clumsy playing a role that no one expects him to assume with total success.

Another image of the family is of a state whose purpose is material survival. This kind of family is recorded in the Bible as the clan or tribe whose home may shift but whose integrity and welfare are tied to a piece of land or to more mobile treasure. The image of the family as a state traveled north and west out of Asia Minor and we find it in the Mediterranean and in Roman portraiture—in stelle, for instance, which show the husband and wife dressed in the robes of citizenry (2.5). In the Middle Ages in Europe families decorated the margins of Books of Hours—collections of psalms and short prayers, richly embellished with a variety of illustrations—where they are shown both at rest and busy at the work which defines their place in society. In the Cleves Book of Hours, for instance, a trio is baking bread and, since we know that baking was a family trade, we can assume this to be a family portrait—of sorts (2.6).

The Renaissance, about which I shall have more to say

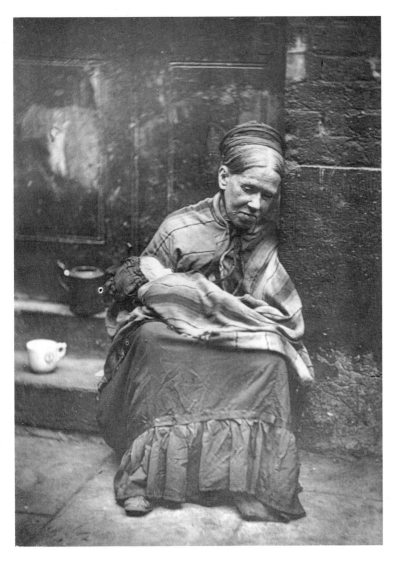

2.1 *The Nightcrawlers;* photographed by John Thomson in London, 1867. Photograph is sometimes entitled *Woman with Baby.* *(Gernsheim Collection, Humanities Research Center, The University of Texas at Austin)*

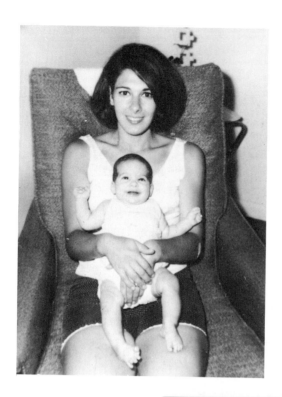

2.2 Mother and son, 1970s
(Author's collection)

2.3 Mother and son, 1930s
(Author's collection)

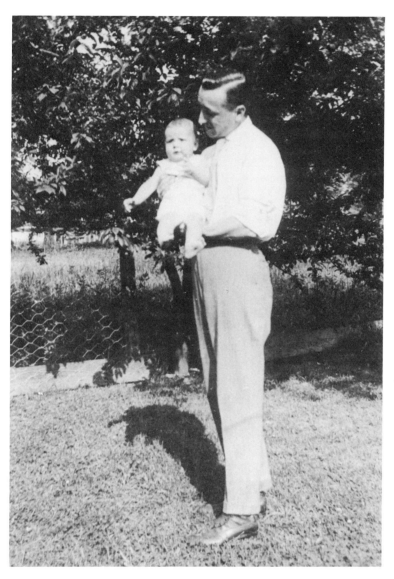

2.4 Man and infant, early twentieth century
(Author's collection)

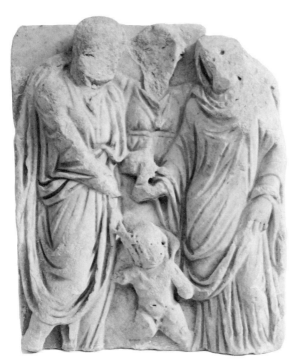

2.5 Roman marriage ceremony, fourth century B.C. *(The Metropolitan Museum of Art, Rogers Fund, 1918; all rights reserved)*

2.6 A page from the Cleves Book of Hours, fifteenth century. The main portion of the page shows St. Philip the Apostle. *(Pierpont Morgan Library)*

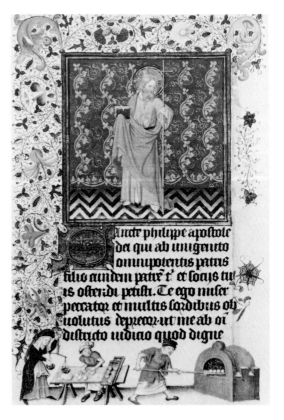

later on, took the family out of the margins of manuscripts and gave it visual independence. The nineteenth century—the century of photography—gave this motif new life when families who moved across Europe to America, or across the American continent, had themselves photographed in front of their homesteads and on the porches of their houses in order to assert their survival and integrity as a clan, as a state. This is the meaning of the image of the Nebraska homesteaders (2.7). All their possessions have been ranged around them, and even the cow, complacently munching the sod on the roof, is there to give evidence that this family of pioneers has "made it." In time the possessions that serve this symbolic function became smaller: today we use the car or the swimming pool as the emblem of the family's conquest of the material world. But the theme of the image is the same: shared possession is the basis of the family. This image comes to have particular force and meaning in documentary photography. In the 1890s, Jacob Riis, for instance, suggested the dignity of the working poor by showing family units laboring together within their own home (2.8), while in the 1930s, Walker Evans photographed indigent families, standing proud and timeless in front of their modest shacks.

The image of the family as a spiritual assembly overlaps with the image of the state. While the latter describes the family's relationship to the physical world, the former describes its share in eternal values. The divinity of the family has special importance in ancient Egypt, in Judaism, in Islam, in early Christianity, and again in Protestantism, all cultures and creeds that give the father judicial and priestly authority and

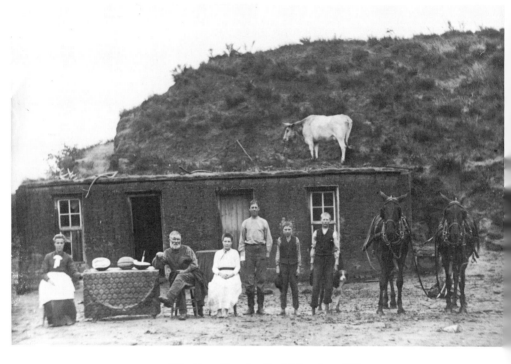

2.7 The Rawding family, Nebraska, 1886
(*Solomon D. Butcher Collection, Nebraska State Historical Society*)

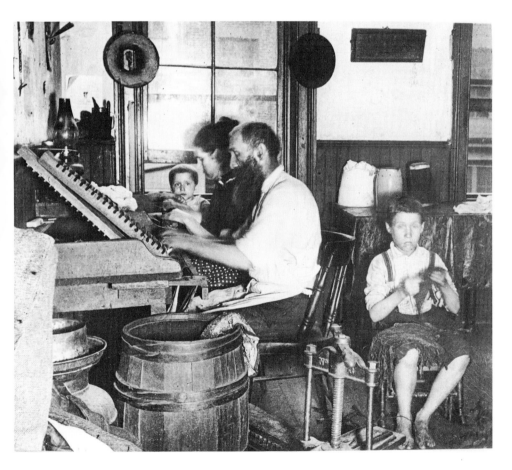

2.8 Bohemian cigarmakers, late nineteenth century
(*Photograph by Jacob A. Riis, The Jacob A. Riis Collection,
Museum of the City of New York*)

the family as a whole a sacred mission. The celebrated bas-relief of Akhenaten, Nefertiti, and their daughters (2.9) is one of the more ancient illustrations of this idea. It is reconstituted in the Christian Holy Family; and it finally touches the portrayal of earthly families in medieval donor portraits such as the one in the Merode triptych (2.10). Here the husband and wife who commissioned the painting are given importance and even a touch of sanctity by their placement near Mary and Joseph.

In the images of both the family as a state, and the family as a spiritual assembly, decorum and self-discipline are imperative; mutual tenderness is at best a charming irrelevance. This view of family life stresses obedience and orderly conduct. But in the Renaissance, political theorists, poets, artists, and ordinary tradesmen, trying to adapt to social change, looked for decorous ways in which love could encompass both heavenly and earthly impulses. The venture is amply illustrated in portraiture. Holbein's study of Thomas More and his family (2.11) honors a devout public servant who presided over his brood like a philosopher-king; while in William Dobson's painting of the Streatfeilds (2.12) the family's austere clothing, their closeness to the symbols of their own mortality, and the placement of the father's hand on the older son's head as if he were blessing him, remind us that this assembly, prey to disease and death, shall survive intact only beyond the grave.

The Dobson portrait is a reflection of seventeenth-century Puritanism for which the family served as surrogate church. And its essential motif appears in all portrayals that suggest that, beyond transitory experience, the family shares in eternal values. The theme underscores wedding photographs in

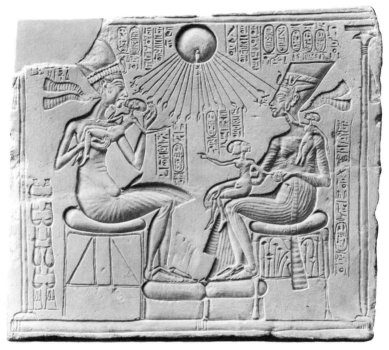

2.9 Akhenaten and family, fourteenth century B.C.
(Courtesy of the Ägyptisches Museum, West Berlin)

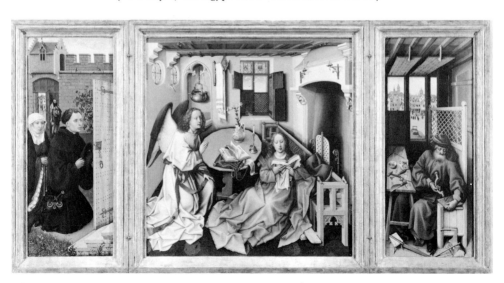

2.10 Robert Campin, *Merode Altarpiece,* mid-fifteenth century
(The Metropolitan Museum of Art, The Cloisters Collection, Purchase)

2.11 Hans Holbein the Younger, *Sir Thomas More and His Family*, 1526
(Courtesy of Kunstmuseum Basel/Kupferstichkabinett)

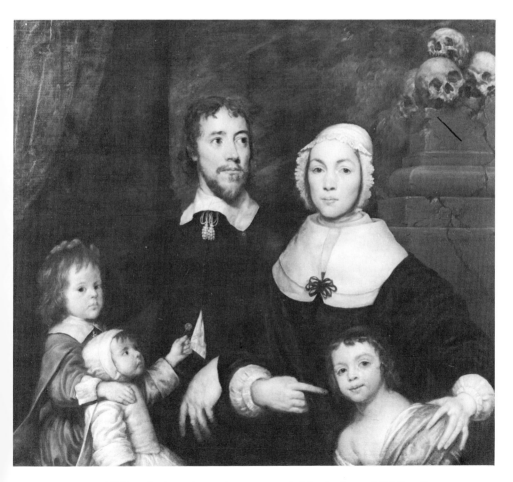

2.12 William Dobson, Portrait group, probably the Streatfeild Family
(Yale Center for British Art, Paul Mellon Collection)

which bride and groom stand in their ceremonial garments and hardly demonstrate their true and earthly ties (2.13) and is expressed in the portrayal of other rites, such as confirmations and bar mitzvahs, which display the family's obedience to religious and communal values. But the specific rite need not be indicated. Spiritual ties can be evoked elusively by the placement of figures in a V or pyramid formation. The person at the base or peak of the geometrical pattern then appears to control those around him, not by virtue of his trade or his possessions, but by the exercise of some invisible authority which has no reference either to time or place. The motif is spelled out in the Norman Rockwell painting of the large clan at Thanksgiving (2.14). The mother brings the turkey to the table because she is the nurturer, responsible for the family's physical comfort; the father stands behind and above her, as befits his priestly authority. The spiritual theme is modified in the turn-of-the-century studio shot of the mother and offspring (2.15). Though central, she neither nurtures nor holds authority. She is simply *covered* by her children. And the 1930s snapshot of the mother, nurse, and little boy (2.16) derives its charm from the child's place in it. The mother, though at the center of the photograph, is not its true focus.

As the nineteenth- and twentieth-century examples of the spiritual motif imply, the mission of the family has changed drastically since the seventeenth century when the strong tie between church and state in Western culture began to loosen. Today we worry not whether a family is in the state of grace but whether it is well adjusted. Pleasure has replaced stability as the most important family goal. And yet we still treasure paintings and create photographs which relate, no mat-

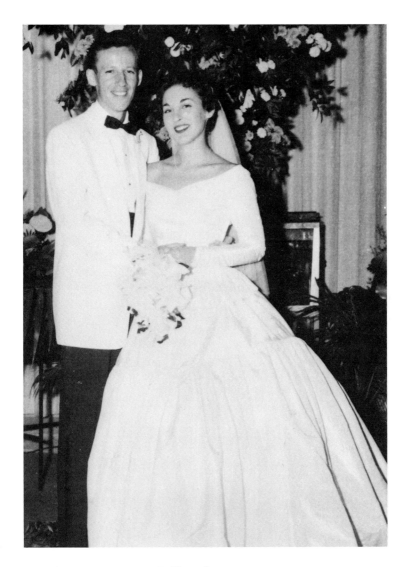

2.13 Bride and groom, 1970s
(Courtesy of Jean Innerfield)

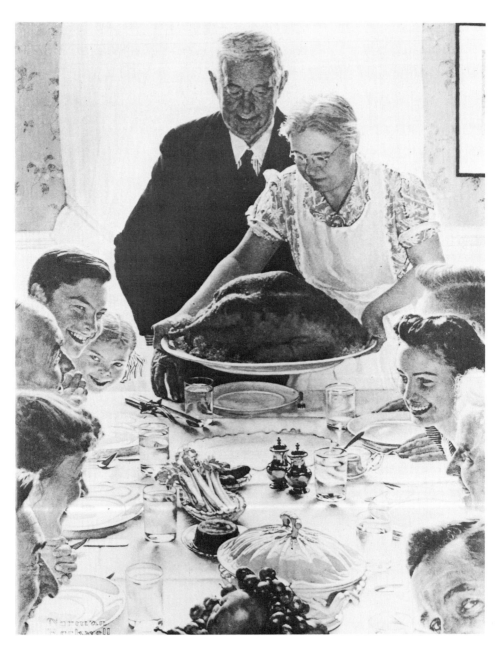

2.14 Norman Rockwell, *Freedom from Want*
(*Reprinted from* The Saturday Evening Post © *1943*
The Curtis Publishing Company)

2.15 Montana mother and children,
late nineteenth century
(Author's collection)

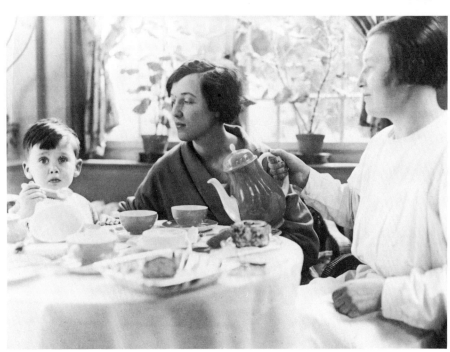

2.16 Boy, mother, and governess, 1930s *(Author's collection)*

ter how tenuously, to ancient metaphors of family unity and cohesion: we still seem to acknowledge the values we have shed.

Contemporary candid photography has made great inroads into personal space—we can find photographs of nursing mothers, naked fathers, and sexually curious siblings—but it continues to avoid marital violence and infanticide, family strife and dislocation. Formal photography similarly masks statistics of adultery, divorce, mental breakdown, and juvenile delinquency. Family photography, like family portraiture, sustains the notion of the family as a corporate entity. Our own family experiences may often strain the idea and Degas, in his study of the Bellelli family (2.17), is one of the first artists to suggest the latent tensions which can inhabit even the best-appointed household. But his entry into the darkness of a family's soul is tentative and maintains the prevailing myth: for all their differences, these four people are still united in the parlor. And the concept of the family as a corporation which no individual will or ego can pull asunder is one of enormous social utility and psychological appeal. It assures us that the family, as an institution, can overwhelm and control our most confused impulses by promoting the triumph of community over self, of history over moment, of the "haven in a heartless world." Family photographs which draw on these ancient themes of unity and cohesiveness sustain the myth. They remind us of our most altruistic hopes and our most unselfish possibilities. No wonder that the sale of cameras and the appeal of family photographs continue to grow.

The definition of the family as an autonomous group—a state, a spiritual unit, a bond of nurturance—independently

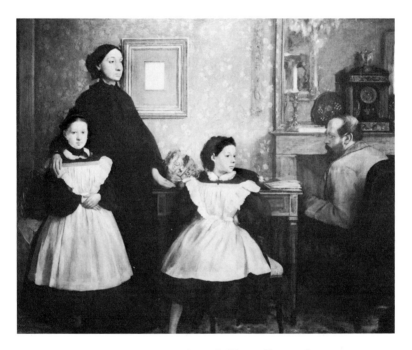

2.17 Edgar Degas, *The Bellelli Family, ca.* 1860
(Musées Nationaux-Paris)

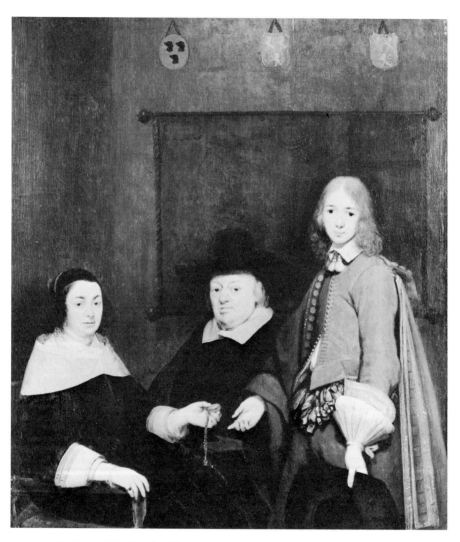

2.18 Gerard Terborch, *The De Liedekercke Family*, seventeenth century
(The Frans Hals Museum/De Hallen, Haarlem)

constituted and self-sustaining, took shape during a time of profound social upheaval. It emerged in the Renaissance and has had unbroken appeal since then, whereas family life itself has endured as many losses as gains. Nineteenth-century historical scholarship accustomed us to view the Renaissance as an era of unremitting optimism. But today we see within it a counterpoint of superstition, civil war, and family breakdown. Mutability and apocalypse go hand in hand with progress as demons of the times. Renaissance family portraits show us cohesive families who, like Holbein's view of the Mores (2.11) and Terborch's painting of the De Liedekercke (2.18), appear as a group of guildsmen who happen to be in the kinship trade. But such decorous portrayals record as much hope as reality, as much faith as fact. King Lear and Henry IV, from the same period, tell us how hard it is to be at once a good parent and a strong king, and how difficult it is for children to give their elders untainted love and devotion.

The Renaissance family portrait is the precursor of the family photograph because it shows the family as self-contained. In the Renaissance the family emancipates itself pictorially, as well as socially, from church and manor; it is no longer a fringe group in a Nativity Scene or a work force subordinated to the baronial estate as in a Book of Hours. It is state, spiritual assembly, loving bond in its own right, with father as lord, mother as nurturer, and children as flock or serfs. Alone, this social unit occupies the entire canvas. And because the family thus depicted appears on the surface to be free from other, external ties, the family portrait becomes a new coat-of-arms: it is the visual boast by which the family can assert

35

its inherent organization and purpose, and display, if it wishes, its conquest of the material world, and its grace in the spiritual. Van Eyck's *Betrothal of the Arnolfini* (2.19) is a paradigm of this double theme. For the artist, whose diminutive reflection shines in the curved mirror at the back of the canvas, has at once united the couple in spiritual harmony—they are both solemn and delicate—and in substance: the painting is their marriage contract, their household inventory.

The Renaissance family portrait thus documents the rewards of spiritual autonomy as well as the benefits of social independence and mobility. Within the portrait, families realize their freedom from the medieval economic and moral order. At any level the family can now have dignity, as in Le Nain's *Peasant Family at Supper* (2.20), or else, as in the scenes of Jan Steen (2.21), it can express the hearty appetites of domestic animals. The Renaissance whittles away at the Aristotelian categories which had once linked high position with tragic grandeur, and low place with bathos and bawdiness. Titian's Virgin (2.22) looks like any earthly mother amusing her baby; while Holbein's wife (2.23) looks remote and long-suffering, her inner eye, it would seem, fixed on eternity. The sacred becomes secular, the profane, noble. The family is free to celebrate what one historian has called "the victory of the family over the family name."[1]

This victory, of course, is not achieved once and for all, nor does it implicate only the family. It also touches on the much larger question of artistic purpose and intent. The seventeenth- and eighteenth-century family portrait undergoes extensive thematic change, of which we find ample evi-

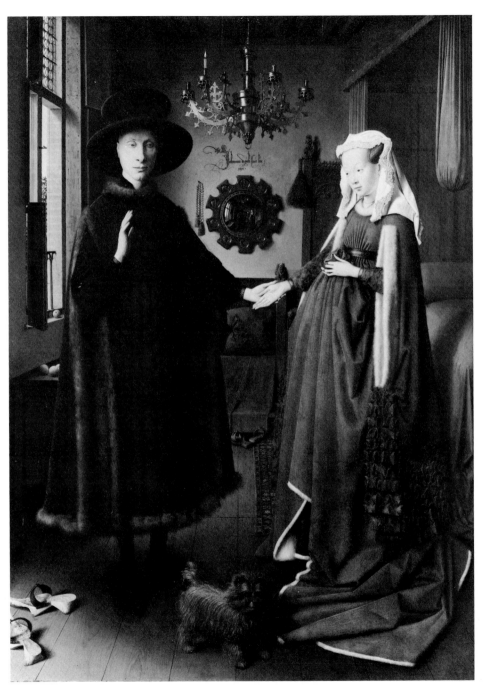

2.19 Jan Van Eyck, *The Betrothal of the Arnolfini*, fifteenth century
*(Reproduced by courtesy of the Trustees, The National Gallery,
London)*

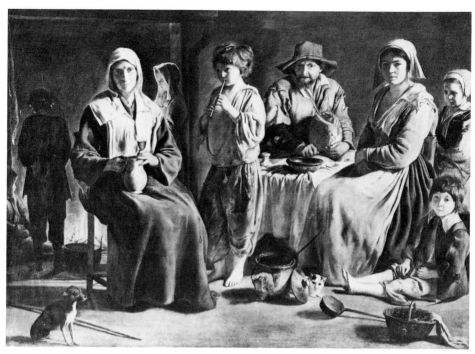

2.20 Louis Le Nain, *Peasant Family at Supper,* mid-seventeenth century
(Musées Nationaux-Paris)

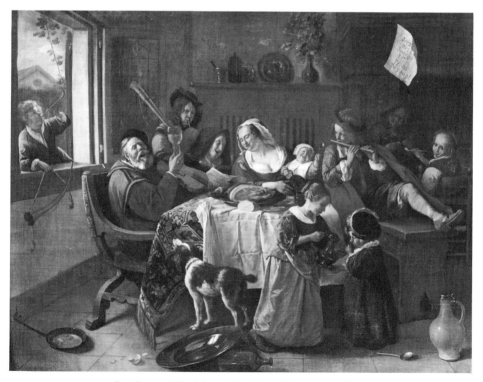

2.21 Jan Steen, *The Merry Family,* mid-seventeenth century
(Rijksmuseum, Amsterdam)

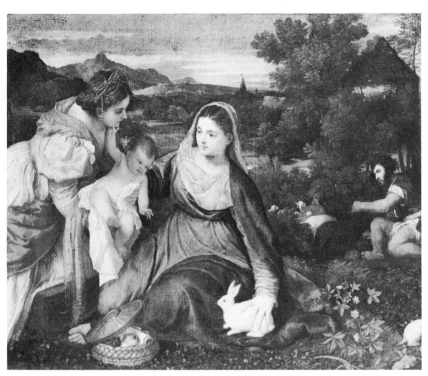

2.22 Titian, *Virgin with a Rabbit,* fifteenth century
(Musées Nationaux-Paris)

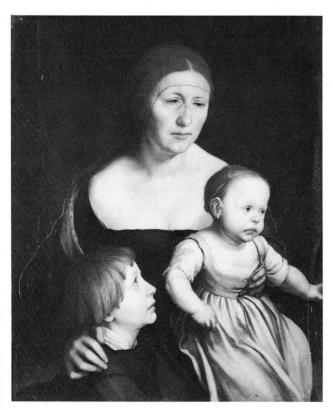

2.23 Hans Holbein, the
Younger, *Artist's Wife and
Two of Their Older Children,*
ca. 1528
*(Courtesy of Kunstmuseum
Basel/Kupferstichkabinett)*

dence in the Devis portrait of the Gwillyms (2.24). The second gentleman at the left, whose hat probably indicates his patrician status, points with the trace of a smile to his wife and children. But the composition of the canvas draws our attention to the splendid mansion at the back and the sweep of the estate. We cannot be sure as we look at the painting whether we are to look first at the property, or at the display of kin. Three motifs are in view here and perhaps no choice need be made in this canvas between the family as an economic interest and the family as an emotional tie, which links man and woman across the strip of grass that separates them in the painting, and focuses on the mother and the children she nurtures. This blending of themes is also common in the nineteenth century and carries over into family photography.

We become conscious of this blending whenever we take our own family photographs. Weddings and confirmations are usually the subject of formal photography because these ceremonies are our share in a feudal and theocratic tradition. Parties, picnics, and vacations are occasions in which feeling is more important than decorum, comfort more important than etiquette, so that the photographs we take are more likely to be candid and to resemble the comic scenes of Jan Steen. But we can manipulate photographic invocations. If we wish to stress feeling more than tradition in a wedding photograph we can show bride and groom kissing, or strolling in a rose garden; and if we want a picnic to summon feudal echoes, we can place its participants around a table and have one particular person, preferably an authority figure, dole out the hot dogs. The metaphors that have shaped family portraiture have also shaped family photography and

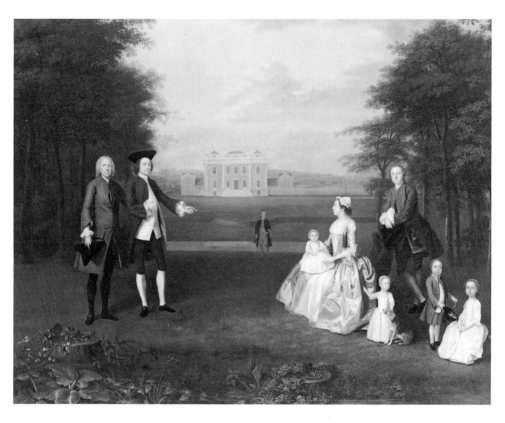

2.24 Arthur Devis, *Robert Gwillym of Atherton and His Family*,
eighteenth century
(Yale Center for British Art, Paul Mellon Collection)

recognizing them enables us to control the allusions our photographs make.

Photography, then, does not abandon the ancient metaphors of family but transforms and spreads them; it brings about a profound social revolution more than an aesthetic one. Families became photographic subjects almost as soon as the medium was introduced in 1839 and in order to compete with miniature portraitists, photographers placed their subjects in the same poses and in front of the same backgrounds that had been popular on wood, and ivory. But with lower prices and greater speed of production, the photograph had the edge of time and price over the painted portrait. Within two generations miniaturists were practically out of business. For the first two decades of its history the most popular form of photography was the daguerreotype, a silvery image on metal; fragile, one of a kind, it was framed in a decorative protective case which gave the image the feel and dignity of an icon. By the 1860s photographs were printed on paper and could be reproduced by the dozen. In this form, *cartes-de-visites* and cabinet prints, as they were called, could be sent across cities and continents. Personal greeting cards, they were in fact used to publish "at large" the triumph of the family over circumstance.

Like the family portrait, the family photograph gained in popularity in a time of social and economic instability. The prim poses and solemn faces which we associate with Victorian photography conceal a reality of child labor, women factory workers whose long hours often brought about the neglect of their infants, nannies sedating their charges with rum, and mistresses diverting middle-class fathers. The latent hypocrisy of the medium is recognized by Hjalmar Ekdal, the

photographer in Ibsen's *Wild Duck* (1884) whose own marriage thinly veils the sexual lapses of his wife and his former benefactor, and whose customers are, like himself, supposedly impeccable householders.

The visual illusions that photography can create are by no means new. Photography simply makes them available to people who once could not have afforded them and so supplies those of modest means with a lasting view of their own faces, and with ancient ideals of family cohesion and purpose. Photography quickly became an equalizing force in society, for all but the most derelict could go to the photographer's studio and have their likenesses taken by the camera. And the photographer's studio, with its choice of painted backgrounds and plaster pillars, used the same settings for rich and poor alike: a democratic aspect of photography which underwent subtle elaboration after the 1880s when the camera became more mobile and could be moved more freely into private and domestic space. Social reality might erode family unity and undermine traditional roles, but the photograph continued to stamp ancient metaphors upon groups of kin whom Western culture had defined as bound to each other by property, responsibility, and blood. "Anyone," wrote a commentator in *Macmillan's Magazine* in 1871,

> who knows what the worth of family affection is among the lower classes, and who has seen the array of little portraits stuck over a labourer's fireplace, still gathering into one the "Home" that life is always parting— the boy that has "gone to Canada," the "girl out at service," the little one with the golden hair that sleeps under the daisies, the old grandfather in the country—will perhaps feel with me that in counteracting the tendencies,

social and industrial, which every day are sapping the healthier family affections, the sixpenny photograph is doing more for the poor than all the philanthropists in the world.[2]

By providing the means by which the poor could see themselves preserved, photography also allowed them to acquire a visual history. The rich had always been able to afford portraits and could surround themselves with painted or sculpted kin. Photography permitted an unprecedented range of people to look at relatives whom either time or space had taken from them. The emotional significance of this gift is ruefully noted by one who lacks it when Pip, Dickens's working-class hero who acquires "great expectations," comments that "I never saw my father, or my mother, and never saw any likeness of either of them (for their days were long before the days of photography). . . ." The opportunity for the poor to acquire a visual sense of their own past, to see before them their own genealogy, and to be able to imagine a posterity that would know their faces, is one of the more important social contributions photography made to nineteenth-century culture, in whose painting and literature the lives of the squalid and disenfranchised are of such abiding concern.

And this gift of visual immortality thrives in our own time. With the accelerated erosion of family purpose and coherence the family photograph has acquired even greater meaning. Photography has allowed us to record our most minute changes with the detail once lavished only on the lives of kings and others of royal blood, and it has broken down those popular medieval and Renaissance equations of poor = social instability; rich = order. In our family photo-

graphs we are all rulers and ruled; all orderly and loving; all noble and modest.

Photography has also enabled us to make the most of time. With our Instamatics and our Polaroids—as well as home movies, still somewhat too costly to be as democratic a medium as still-photography—we can now track not only the growth of our children and the erosion of our own bodies, but also the succession of our homes, our pets, and our spouses. The past is always at our fingertips, always available on paper or plastic for instant replay. The moment as we experience it is a little less important than it used to be: it can always be "taken" and stored for later review. We now weep a little less for our losses, our relentless changes, because the evidence of photography prevents our nostalgia from embellishing too much the actual features of our past. Our snapshots are always there to remind us that our first home was not really so big, our favorite uncle not really so handsome, the steps on the landing not really so high. Photography has transformed our memories from narrative, from diaries and letters, to pictures and sounds. We make tapes and click our cameras. We can hear and see more, but we understand less. Photography celebrates the details, while it obscures the ironies, ambiguities, and contradictions of life. The present is trivialized. Family photography does not preserve the shadows of our experience but rather their external share in ancient patterns. And these patterns are finally indicated by the inherent definition of the family as a corporation, which gives the photograph its overall structure, its settings and poses. These too, like the three metaphors of the family with which I set out, derive from pictorial tradition. But today we no

longer imitate paintings, we imitate other photographs. It is from these that we learn to use place to invoke the metaphor of the family as a state; depth to invoke its image as a spiritual bond; and facial expression to invoke its image as an emotional bond.

3

Place and Time

LIKE PROSPECTORS WITH DIVINING RODS, we carry our cameras with us in search of treasure, and look for the strike—the perfect picture—wherever the family gets together, indoors or out. The family photographs we take provide information about the layouts of rooms, the styles of furniture, the size of houses, the menus at picnics. They also invoke all the symbolic meanings which place and time have for us as beings in culture and society.

Photographic space begins in the viewfinder. We shift our camera around looking for our subject through its square or rectangular eye. We play spatial games with the camera, too: we center our subject to suggest order, we tip it to create humor, we tilt the camera this way to enlarge a room, we skew it that way to give a narrow porch a more gracious sweep.

The places we photograph are our roots. Family photographs are taken in backyards, on streets, in parks, in kitchens, in front of the house, in the driveway, next to the car, in all the places we scratch, stain, dent, and wear out as we move through our lives as children, siblings, spouses, and parents. But the place we first found in the viewfinder is not the place

to which we return in the photograph. The place we took was innocent of the emotion with which we revisit, and where we now read of decline or progress there was initially only a moment in time.

Family photographs show us both the outer and inner spaces of family experience, and all the knick-knacks, porches, and table settings we find in them are balance sheets of money had and money spent. Entire houses, housefronts, and stoops, in varying scales and proportion, show us the family's territory, symbolic of its place in the world. The Devis portrait (2.24) is as clear a declaration of property as we can ever find in portraiture: it links the landscape, the mansion, the elegant adults, and the sweet children—the heirs to the estate—into a quiet statement of privilege and power. We know this family by the scale and size of its property.

The photograph of the Nebraska settlers (2.7) in the midst of the wilderness they have carved into their estate shows us an entirely different society and situation, but the meaning of the photograph is the same. Although the sod house is in reality far smaller than the eighteenth-century mansion, it stands in comparable scale to its owners: like the Gwillyms, the American family looks just as heroic in front of its home and is also identified by and with its real property. In both these views, scale is a clue to meaning. These families, appearing larger than the homes that shelter them, are in control of their lives. We need not know their names to know who they are.

Scale carries simple implications and determines how we read space. In the Van Schaick photograph (3.1) the relation of people to setting says little for them. The house looms darkly

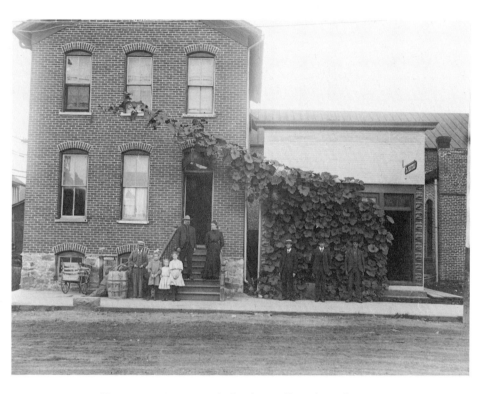

3.1 Charles Van Schaick, *Black River Falls, Wisconsin, ca.* 1900
(State Historical Society of Wisconsin)

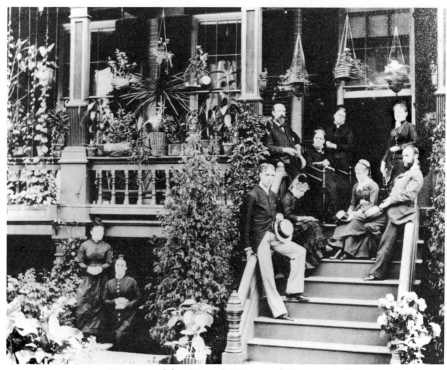

3.2 Drummond family, 436 West 22nd Street, *ca.* 1875
(Museum of the City of New York)

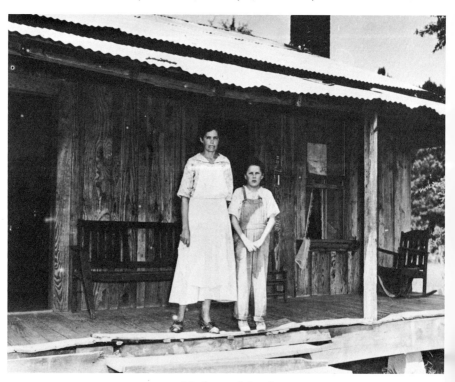

3.3 Mother and daughter
(Courtesy of Richard W. Leche Papers,
Department of Archives, Louisiana State University)

over its residents and we can hardly identify a family con-
stellation. The house may be a more valuable piece of prop-
erty than the Nebraska sod dwelling, but its scale obscures
the figures who stand before it. It is not so much the elabo-
rateness of the territory that impresses us in a family photo-
graph as the relative size of people to place. The larger the peo-
ple the more we attribute to them the ability to control the
world around them.

The simplest way of suggesting spatial mastery outdoors
is to show a housefront or a stoop, symbolic pieces of terri-
tory. Porches, doorways, flights of stairs, appear again and
again in family photographs: they are discreet fragments of
an address. Architecture often dictates who stands where, but
as long as scale highlights people, we continue to read in
such pictures themes of control and domination. We ask no
questions about the value of the house, the cost of rental, or
the length of the lease. An unknown photographer, making
the most of a leafy veranda (3.2), has arranged the Drum-
mond family of New York for presentation: the men with
hats in hand, the two women at the bottom left with their
hands folded (servants, perhaps, coming up from downstairs),
the older woman at the top right, the young women with
downturned eyes, each is posed to set off the elegant lines of
the house. We do not know how they are related to each
other; we do not know their precise claim to this location.
But the harmony of people to setting satisfies us that they all
belong here.

The 1930s photograph of a Louisiana mother and daugh-
ter (3.3) also uses a housefront as a symbolic complement to
those who live within. The photograph, taken by a WPA
worker, serves, like so many others of the era, to illustrate the

endurance of the poor. The official records describe the daughter as suffering from a glandular disease; and the appearance of the porch itself tells us enough about the mother's experience. Under the warped metal roof, the bench is squared with the wall, and the curtain which trails out of the window suggests a touch of gentility. The housefront confirms the great effort necessary for these two women to be a family at all.

The least we ever see of a house is a pattern of lines and textures: hardly an address or symbol of property. We have already seen the effect in the 1890s photograph of the Connecticut family (1.4). We see it again in three snapshots taken within the last thirty years. Each of these photographs shows a celebration to which the house itself is only an insignificant backdrop; we can barely see a front entrance. The little girl observes her first communion surrounded by her relatives (3.4), but it is the event that the picture commemorates, not the place. A family reunion of three generations is set against a housefront (3.5), but the focus of the shot is on a significant moment, not on the site where it happened. In the photograph of the two sisters in front of their family car (3.6), the house has been upstaged by a vehicle, a symbol of permanence by a symbol of mobility. These photographs, taken between 1940 and 1975, illustrate the growth of suburbia and the rise of car ownership which we associate with those decades.

But we should read these images as social history only with caution. Houses and housefronts have had limited use in family portraiture for the last four centuries; and photography has not contributed to their meaning. In contrast, indoor space—with all the opportunities it offers for the close

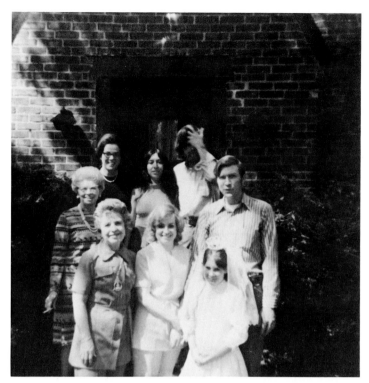

3.4 Girl at confirmation with her relatives, 1970s
(Courtesy of the Kiernan family)

3.5 Family reunion, 1950s
(Author's collection)

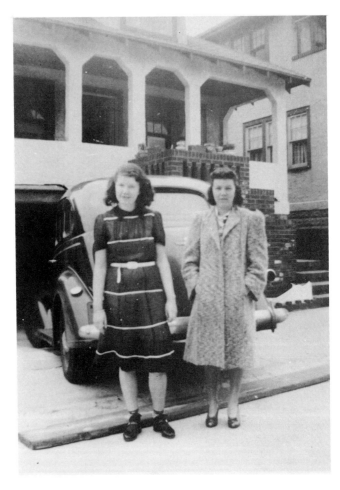

3.6 Sisters and car, 1940s
(Courtesy of the Kiernan family)

observation of things and textures, has had far more impor-
tance. When Van Eyck painted his portrait of the Arnolfini
(2.19) in 1434, he included a meticulous household inven-
tory: windows (at that time a costly commodity), shutters,
canopy bed, slippers, dog. Van Eyck's portrait is not only a
visual catalogue of the couple's property; it is also a reflection
of their inner state. Next to the mirror, symbol of all the
world's vanity contained in the room, hang rosary beads, em-
blems of prayer, and the groom holds his right hand in a ges-
ture of blessing as if he were sanctifying his domain. He is
not only a rich merchant, but a king and a priest, presiding
at once over his home, his state, and his church.

Van Eyck's sense of private space as a key to the moral
condition of those who fill it becomes a commonplace in the
centuries of portraiture that succeed him. The farces of Jan
Steen, the small daily rites of Vermeer, the comedies of
Hogarth and Rowlandson use parlors and kitchens like stage
sets full of clues about the habits and values of those who live
within them; while in the late eighteenth and early nine-
teenth centuries Fragonard and Greuze turn the nursery into
the seat of family feeling. Degas's portrait of the Bellelli fam-
ily which we looked at earlier (2.17) uses indoor space with
an awareness that the rooms in which we live as families are
charged with tension and even with tragedy. We find the ef-
fect again decades later in some of the photographs of Diane
Arbus. Degas pays close attention to surface textures but turns
the family's gracious parlor into its dungeon, with the father
sealed off in his corner of desk and table legs, and the mother
and daughters stranded on their island of carpet.

The rooms we see most often in family photographs are
the ones in which we receive our guests, the living room and

the parlor, but until recently it was seldom the kitchen and never the bedroom. These are the places in which we display our furniture, our pianos, our good carpets and china, even our photographs, the places in which we are on our best behavior not only for company but also among ourselves. The photograph taken in about 1917 (3.7) is full of property: the piano, the clock on the mantelpiece, the books, paintings and knick-knacks, the well-cut clothes, and incongruously, even a swatch of long underwear peeking out from above the gentleman's boot. The 1950s snapshot of a well-groomed family in its own living room is also filled with signs of income and class (3.8) and, with couch, mirror, and coffee table, is as penetrating a view of a way of life as Van Eyck's *Arnolfini*. Family photographs taken indoors between 1870 and the middle of the twentieth century often seem in fact to dazzle us with goods, a feature that results in part from styles of design that favor abundance and variety. But these pictures, which, like the two we have just looked at, appear to be celebrations of Manufacture, are not found only among photographs: they share in a general aesthetic preoccupation with home and family which John Ruskin, in 1867, characterized as "the Art of the Nest,"[3] an obsession with domestic "little things" which he deplored because of its lack of civic and intellectual responsibility. Family photography, with its careful inclusion of "little things"—the indoor version of land— is often guilty of Ruskin's charges. The late nineteenth and early twentieth centuries are not, of course, without their records of families who want for abundance—the haunting subjects of such documentary photographers as Jacob Riis and Lewis Hine. But, until the manufacture of the inexpensive box camera, those of modest means are seldom photographed

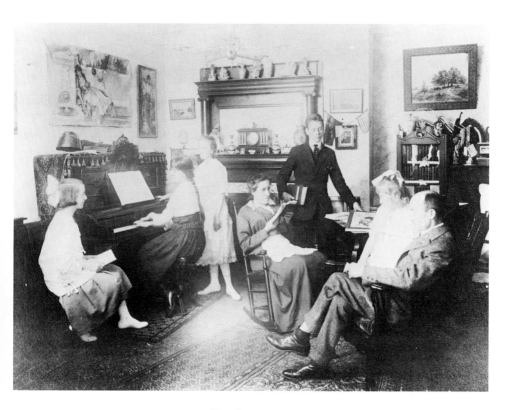

3.7 Family group, 1917
(*Museum of the City of New York*)

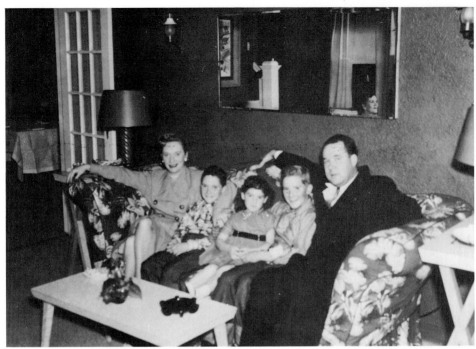

3.8 Seated family, 1950s
(Courtesy of the Kiernan family)

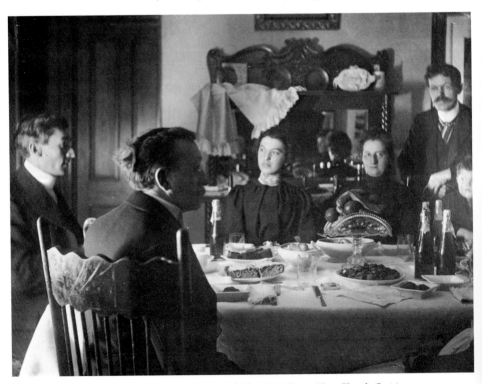

3.9 Harry E. Dankoler, *The Dankoler Family at New Year's Supper,,
Wisconsin, January 1, 1900*
(State Historical Society of Wisconsin)

by members of their own class and indoor family photography is most commonly a celebration by the affluent of their own prosperity.

Possessions, so telling a feature of photographs taken in living rooms and parlors, lose some of their importance in those taken of a family at mealtime. In such pictures we are often still aware of specific rooms—a dining room, a kitchen, a den—and particular material objects, such as serving dishes, a sideboard, a crumpled napkin. But mealtimes draw our attention away from the space the family occupies, to the occasion that brought it together. In the quiet view of *The Dankoler Family at Supper, New Year's, 1900* (3.9) we see an array of fine dishes and attractive goods. The family is not actually eating, but we have ample evidence that soon they will be, and all the signs of prosperity do not alter our realization that some fundamental necessity is about to be dealt with. Pictures of family meals, as van Gogh recognized in his paintings of the *Potato Eaters* (3.10), are not only about nourishment but about effort, fulfillment, and community. In van Gogh's canvas, as in the two snapshots of family meals (3.11 and 3.12), the table settings are simple, but we have no trouble recognizing the necessity and the rites they imply. And if we look at all these pictures together—the gracious, the modest, and the haphazard meals—we are struck less by the differences in styles of clothes and of living, than by their portrayal of a simple human imperative.

The photographs of family meals often record another event—anniversaries, religious holidays, weddings—whose meaning subtly overwhelms the personal aspect of the picture and fills it with allusions to tribe and to ritual. The photo-

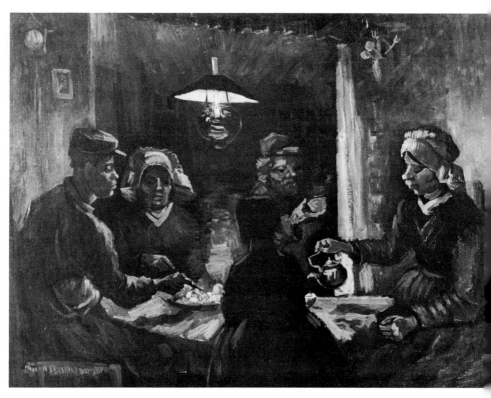

3.10 Vincent van Gogh, *The Potato Eaters*, 1885
(Rijksmuseum/Kröller-Müller, Otterlo)

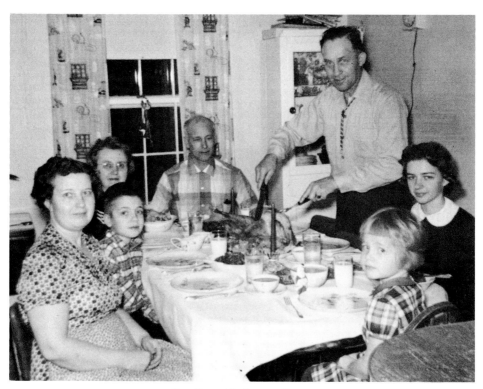

3.11 Family at Christmas dinner, 1957
(Courtesy of Nancy Amy)

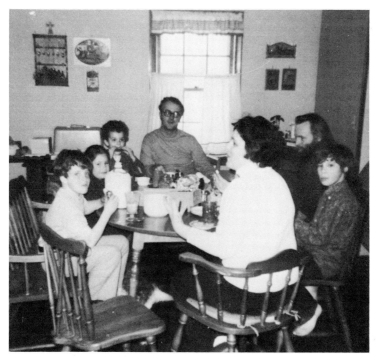

3.12 Family meal, 1960s
(Courtesy of the Kiernan family)

graph taken in New York at the turn of the century (3.13) shows a couple celebrating their golden wedding anniversary. But their age here is not their own; it belongs to the relatives who surround them. The snapshot taken next to a seder table (3.14) shows three generations. The father is flanked by his mother and daughter, while three portraits of his children cover the wall. But family is only part of the picture: the objects on the table tell us what calendar the family observes and turns the view of a family into an image of spiritual loyalty.

Confirmation and wedding photographs—pictures of families obeying custom and religion—also subordinate a personal sense of time and place to the demands of ritual. When we look at the photograph of the couple in their wedding outfits (2.13) we do not care whether it was taken, like so many other ceremonial photographs, a day before the wedding, or three hours later; we care only that the man and woman look like a bride and groom and uphold the decorum of formal weddings. "Today," comments a professional wedding photographer, "it is common for one set of parents to be divorced, and although they will bring new spouses to the wedding, when it comes time for group pictures, they often ignore the new wife and Daddy poses with his old wife."[4] We don't mind if wedding pictures lie as long as their deceptions uphold the tradition that the photograph is meant to honor. In such a photograph, location is insignificant: we merely expect it to complement the rite celebrated. We are not concerned whether the couple is in rented clothes, in a rented hall, in a photographer's studio, or in its own living room. It is the ceremony of their union, not their relation to a particular place, that is important. In the snapshot of the couple next

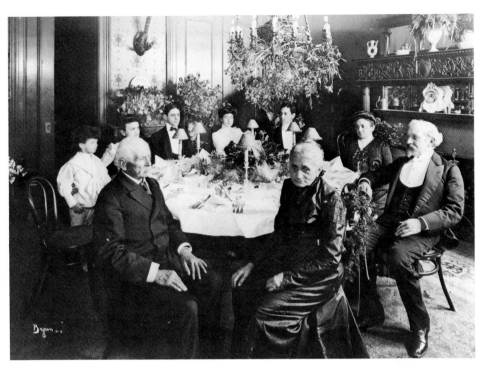

3.13 Golden wedding, 1902
*(Photograph by Byron, The Byron Collection,
Museum of the City of New York)*

3.14 Three generations at Passover, 1970s
(Courtesy of the Nelson family)

to a Christmas tree, place also matters little. What the photograph does tell us is that they observed an annual rite (3.15).

Custom's calendar, so clearly etched into photographs of rite and ceremonies, is usually put aside in pictures of family vacations. Vacations are themselves meant to remove us from necessity, production, and even propriety, and any pictures taken merely record breaks in routine. We seldom learn from them how a family usually lives. Whereas rites and ceremonies invite formal photography, which interprets our conduct in conventional patterns, vacations are most often recorded in candid photography; for this reason we find relatively few pictures of family picnics and visits to the beach before the 1880s when candid photography comes into existence. We may take time off in our backyards, in the park down the street, on a remote island, in a famous city: but in our family vacation photographs these places appear as mere backgrounds which we do not affect or shape the way we do our everyday lives. Since we cannot distinguish between our everyday lives and *time out* in a photograph, vacation pictures, more than any other class of image, call for narrative—as we know from all those friends and relations who have insisted on *showing* us how they spent their vacations. The mother and daughters flanking a cannon (3.16) were tourists, but we need their word to find out that they were not the caretakers of the property. In the same way, the snapshot of a woman with outstretched hands (3.17) calls for an explanation. She was an American on vacation in Israel with her husband and children; it was he who took the shot just as she was feeling for rain, as some chance drops happened to fall on their sunny picnic. The photograph would have an entirely different meaning to her—and to us—if she had been an

3.15 Husband and wife at Christmas time, 1960s
(*Courtesy of the Kiernan family*)

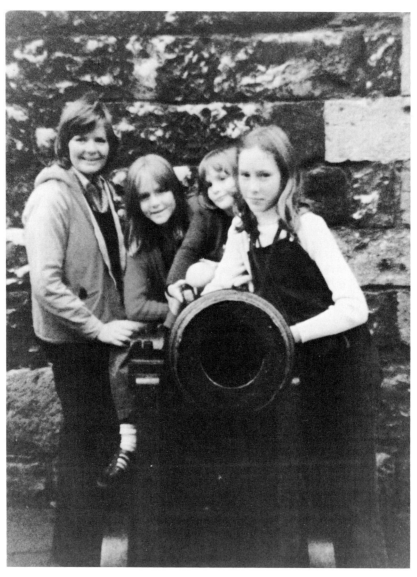

3.16 Mother and daughters on vacation, 1970s
(Courtesy of Kathy Ebel)

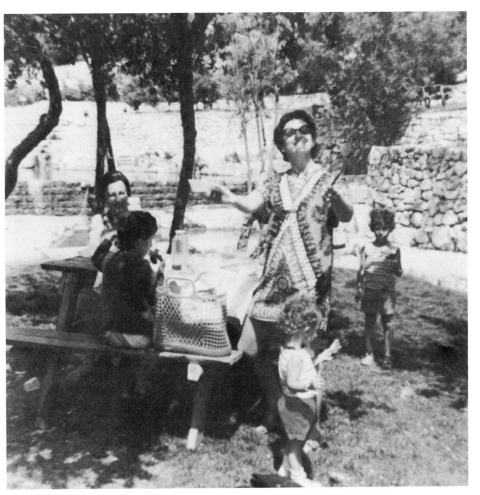

3.17 Mother and children on vacation, 1970s
(Courtesy of the Nelson family)

archeologist on a dig. Vacation photographs, like these two, record temporary interludes in our usual histories, yet they also illustrate the strength of our ties. "Even here," they seem to say, "we still were a family."

In addition to the Edens we revisit while on vacation, one other place—the photographer's studio—has offered the family photographic refuge from its own history. Throughout the nineteenth century and well into the twentieth, photographers' studios were equipped with a variety of painted backgrounds against which clients could pose; today these synthetic and often idealized scenes are used mainly in formal wedding and confirmation pictures. At the height of their popularity in the late nineteenth century, the variety and skillful execution of these backgrounds were a measure of the photographer's own professional standing. The studio we see here (3.18) is a fairly well appointed one, with its decorative screens, Renaissance-style furniture, Chinese-style vase, and drapes. The pictures mounted on the wall are probably the photographer's own work and give us an inkling of how he used these various props and backgrounds. Most studios also had special chairs with holes in them, for young infants, whose mothers could crouch out of sight and hold their heads still while the photographer was taking the picture. Mora, the celebrated theatrical photographer, offered his clients some 150 backgrounds to choose from, including scenes of tropical islands and jungles. In their sweeping variety, the backgrounds and furnishings of photographers' studios reflected many of the tastes of the times; and we find in studio portraiture dozens of Renaissance, Romantic, and Gothic echoes, including libraries full of leather-bound books, pillared galleries, crumbling terraces, ivy-covered ruins, stormy

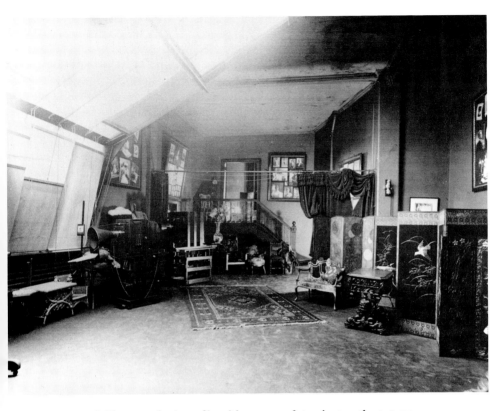

3.18 Photographer's studio with cameras, late nineteenth century
*(Photograph by Byron, The Byron Collection,
Museum of the City of New York)*

skies, and Roman statuary. These effects are not attempts at historical re-creation, but ways of giving the photographic image some of the imaginative qualities of painted portraiture.

The availability of such disguises to anyone who could afford to have his picture taken by a professional made the photographer's studio a chamber of fictions, offering clients spatial illusions where they could escape from the evidence of their material successes or failures: the kind of evidence that would inevitably be found in their own living rooms, parlors, and housefronts. These studio portraits (3.19; 3.20; 3.21) look astonishingly alike even though they were made thousands of miles apart, and the visible uniformity of the photographs hides from us the fact that one couple were lace merchants from Brussels (3.19), another a farming couple from Indiana (3.20), and the third unknowns from Ontario (3.21). In photographic studios, standing in front of elaborate furnishings, these three sets of people have shed their histories, and assumed a homogenized air of propriety. These pictures show us why people went to professional studios. Not only did studio photographers guarantee a "quality" product which could be bought by the dozen, ready for distribution, but they granted clients temporary immunity from reality. Here the immigrant and the socialite, the laborer and the clerk, could all occupy the same space: no one had to sit at the back of the bus. Queen Victoria herself loved to have her picture taken, especially by J. E. Mayall, and in 1860 she appeared as the eager subject of the *Royal Album*.

But few studio images fool us entirely: most contain some subtle incongruity which makes the background reveal its shallowness. The Indiana couple looks a bit too grim to be at

3.19 Husband and wife, late nineteenth century
(Author's collection)

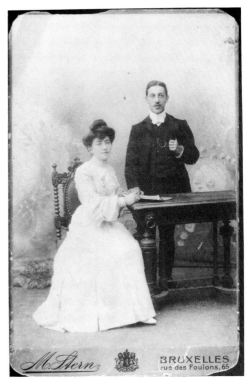

3.20 Husband and wife, late nineteenth century
(Courtesy of Betsey Neugeboren)

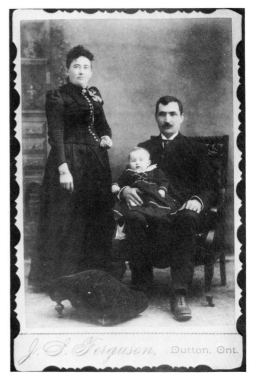

3.21 Family, late nineteenth century
(Author's collection)

home amid so much sensuous detail; and the dull, heavy boots on the Ontario father, and the short sleeves and ill-fitting bodice on his wife show that they do not really belong here. Only the Brussels couple, in their elegant clothes and traces of jewelry, look right where they are. Many of the studios we see in formal family portraits are themselves poorly appointed. In the picture of the small family, flanked by two sisters (3.22), the floor boards practically creak in front of the painted waterfall. In the shot of the parents and small child (3.23), the disproportion between the painted boat and its passengers makes the family look forlorn when they may simply have been uncomfortable, crammed in their best clothes into such a small place.

By the turn of the century, grottoes, ruins, and lush forests gradually disappear from the studio. Backgrounds, like the painted lake in the picture we just looked at, begin to show places the persons photographed might easily have visited. The young couple posed by a fake rock (3.24) could actually have gone to a real beach and the sisters (3.25) might have ice skated on a pond. The painted background changes from fantasy to actuality. This visual descent into ordinariness also leads to entertainment. The painted background inspires the painted cut-out, a popular feature of photographers' stands at carnivals and fairs. Stick any face inside a domestic scene, like the one of the bonneted housewife and her "dirty boy"—(3.26) a photograph taken by Paul Martin at Yarmouth—and you will create an instant domestic farce. The contemporary photograph of a young couple inside a flower-edged heart—taken in Upper Volta (3.27), where older European styles are still a novelty—turns them into a giant Valentine. Today painted settings are used with serious in-

3.22 Two sisters and another family
in a studio, early twentieth century
(*Author's collection*)

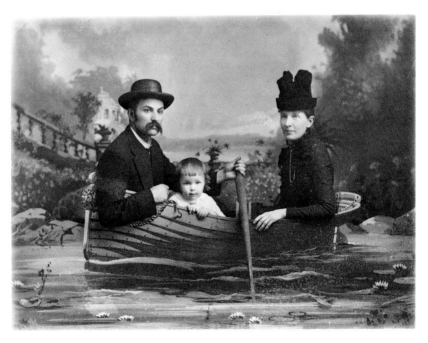

3.23 Charles Van Schaick, *Family, ca.* 1900
(*State Historical Society of Wisconsin*)

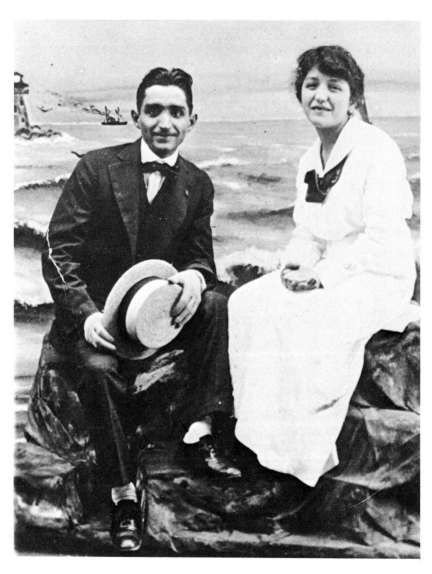

3.24 Husband and wife, early twentieth century
(*Courtesy of Jean Shapiro*)

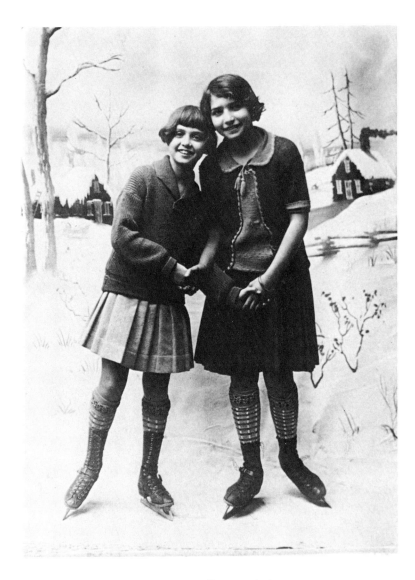

3.25 Sisters in a studio, twentieth century
(*Courtesy of Jean Shapiro*)

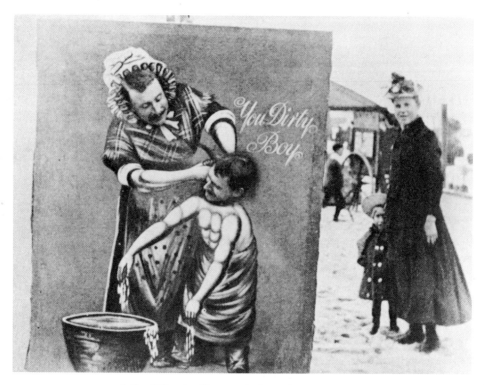

3.26 Paul Martin, Yarmouth, late nineteenth century
(Courtesy of Arno Press, Inc., reprinted by Arno Press, Inc., 1973)

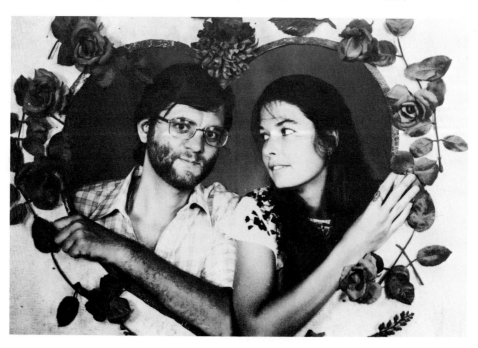

3.27 Husband and wife, 1970s
(Author's collection)

tent only in formal studio portraits, in which both the photographer and the subject want to know ahead of time what the overall invocations of place will be within the photograph.

Such control can also be achieved by the use of plain backgrounds, popular from the very beginnings of photography, and still in wide use today. The plain background, which can be a pastel cloth in the photographer's studio, or a blank wall in the amateur's living room, frees the person in the picture from the grip of any spatial allusions at all—he seems to be both everywhere and nowhere—and allows the photographer and the viewer to look at faces and bodies unencumbered by allusions to place, to time, to work, and to possessions. The family photograph taken without such clues focuses far more on personalities and relationships than on activity and experience. The photographer who takes his subject in a scenic background—painted or biographical—acts as a producer putting together a stage design; the photographer taking his subject in front of a plain background becomes a psychologist, perhaps even a philosopher, concerned with ultimate human values. This perceptual advantage of plain backgrounds makes them one of the more ancient devices of portraiture: we see them in Roman mosaic, in the portraits of Holbein and Rembrandt, in the photographs of David Octavius Hill and Julia Margaret Cameron. Plain backgrounds, of course, are also required in passport photographs and mug shots, pictures in which physical features themselves are all that matter.

Family photographs taken in front of plain backgrounds draw our attention to bonds and configurations spelled out in the line of a hand, the cast of an eye, the angle of a mouth: all the poignant evidence of faces and bodies. The plain cur-

77

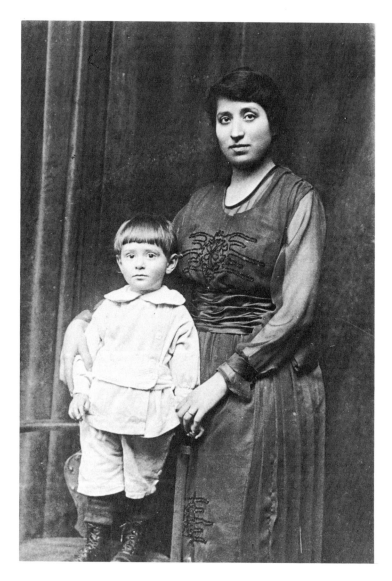

3.28 Mother and son
(*Courtesy of Jean Shapiro*)

tain behind the Montana mother (2.15) helps us to focus on her pivotal place in the photograph. Her children, easily draped about her, look relaxed, as if nestling against her were an ordinary occurrence; all but the baby are visibly touching her. This little huddle of humanity makes allusion to no particular task, and to no particular event, only to closeness itself, a gesture in time, and also an evocation beyond it. In the 1920s portrait of the mother and son (3.28), the plain background highlights the contrast of features. Our vision is drawn in to focus on eyes, cheekbones, and the mother's lightest touch to steady the little boy. These scant details are enough to signal an essential tie which we all recognize and value. In these pictures, the vital spaces that the photographer allows us to probe—and that the subject invites the photographer to examine—are no longer a material environment of which the subject is part, but the subject's own inner landscape, to which the photographer and the viewer are, at best, only invited guests. Stripped of material clues, the family photograph becomes a view of "unaccommodated man" who, like Lear on the heath, exists beyond the world of things and time.

4

Faces and Bodies

THE MOTHERLY WOMAN, the fatherly man, the tender child: we carry them with us in memories, in dreams and pictures, and in all the places where longing and history assemble to reshuffle experience and deal us new parts. Was that look of care, or of tenderness, that clasp, sufficient or wanting; and how could the hair once have been so long, the dress so short, and the shoes so tight? The questions are like probes, and the answers often lie within our family photographs, which change before our eyes as life gives them new meaning. Family photographs are as personal as fingerprints. But they are also as public, as subject to fashion, as are clothes, and all those pictures we treasure as our very own rely as much on the roles and glances the world has been willing to recognize, as on the looks and expressions we are willing to show. Family photography is not only about genetic traits and property; it is also about the relations and behavior which culture has assigned to kin.

Style is habit, and photography has assumed two habits in portraying the family. In formal photography, families face the viewer and try to look united, stable, and dignified. For-

mal photography deals with character. The habits of candid photography differ not so much in kind as in tone. Candid photography is about personality: it makes the most of feeling, of impulse, of accident. The incidental gesture and the chance grin which destroy the decorum of the formal portrait give energy to the candid one.

Until the development of the box camera in the early 1880s, nearly all portrait photography was formal and both professionals and amateurs needed a solid understanding of photochemistry to produce a creditable picture. Photography started out as a cumbersome craft, needing a strong back and strong arms as much as a good eye: equipment was heavy, awkward, and temperamental. The first generation of cameramen and subjects were bound to each other in a tedious partnership which required discipline and self-control, and many a dignified couple, eager to have their features immortalized, found themselves, like the pair in Daumier's print (4.1), trapped with their heads in a vise. By the 1850s exposure time was well under a minute: subjects could allow their facial muscles to relax and their eyes to blink without fear of spoiling the picture. But even when technology no longer called for rigid postures and facial immobility, formal photography continued to favor composure and dignity: turn-of-the-century cameras *could* easily have captured this family trio (4.2) vivaciously laughing together.

A cultural bias is at play here. The success of portrait photography did not grow out of its way of seeing, but out of its inexpensive way of making pictures. The first family photographers were not aiming at stylistic originality but at commercial success, which came to them quickly because they were able to produce cut-rate versions of painted portraits.

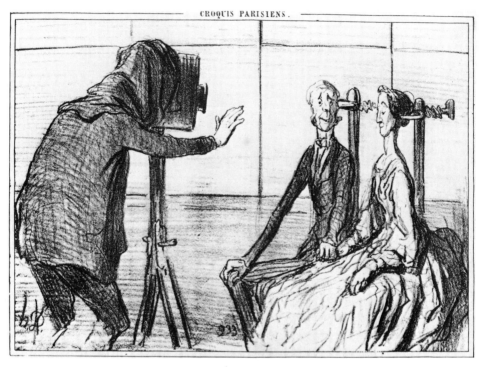

4.1 Honoré Daumier, *The New Process*, 1856
(The Metropolitan Museum of Art,
Gift of E. de T. Bechtel, 1952, all rights reserved)

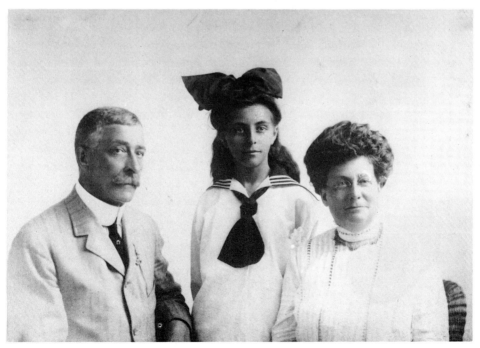

4.2 Family, early 1900s
(Author's collection)

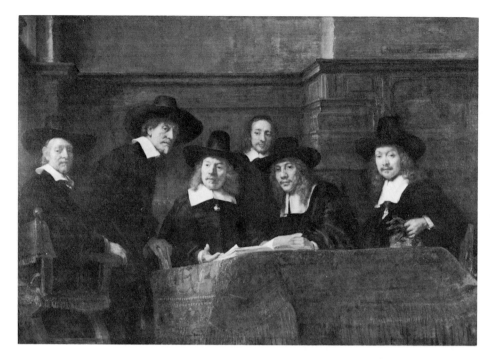

4.3 Rembrandt van Rijn, *Syndics of the Drapers' Hall*, 1662
(Rijksmuseum, Amsterdam)

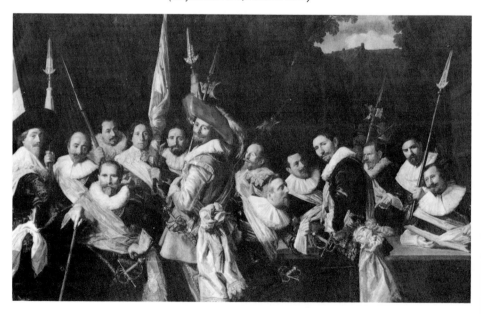

4.4 Frans Hals, *Schutterstuk*
(Officers of the Guild of Archers of St. George), seventeenth century
(The Frans Hals Museum/De Hallen, Haarlem)

And the habits of painted portraiture which they imitated wholesale were aristocratic, and committed to grace, to elegance, and to decorum.

The very furnishings of photographic studios—which we can read out of all the pictures that were taken there—document this cultural bias. We have already examined their typical contents, which reflect the nineteenth-century taste for Renaissance styles. In front of the heavily wrought chairs and plump drapes of the studio it was perfectly appropriate to avoid mirth and banter, for only by looking august could photographic subjects hope to resemble the heroic figures of former times who might have lived among such trappings. Put a shopkeeper into a heavy chair, drape a fringed bolster behind him, plant his feet firmly before him, place his arms squarely on the arm rests, and, if he sits still for a few seconds, he might just come across in the photograph looking like a king.

The Renaissance was so influential in setting the habits of formal portrait photography because it established the art of portraiture which immortalized newly rich merchants, guildsmen, and craftsmen as well as kings: it gave face and stature to the same class of people who three hundred years later flocked to the photographic studios to have their "likenesses" taken. The formal family portrait painted in the seventeenth century resembles group portraits like Rembrandt's *Syndics* (4.3) and Hals's *Schutterstuk* (4.4). To identify the guild officials and the militia men, heavy books and pikes, suggestive of their respective roles, were included. Comparable signs for the family were by this time more difficult to find, for what, after all, *were* the symbols of the family? And in what sense was to be part of one to be part of a profession?

Once, as we have seen, these questions had been answered quite simply. A family worked together as in the Cleves Book of Hours (2.6) and they shared the same household, as in the Da Costa Book of Hours (4.5). The tie was economic. But family, as we know from Van Eyck's Arnolfini (2.19), can also mean a spiritual bond: it can be the Holy Household which we see in the Cleves Book of Hours (4.6), a manuscript contemporary with Van Eyck's painting. The Infant Jesus pads about in a walker, Mary is making lace, and Joseph is doing some mending—a domestic scene presented more stiffly in the later Campin Altarpiece (2.10). The family's unity is not turned outwards toward work and property but entirely inwards: it is an atmosphere, a mood, an emotional tone, as easy and warm as Degas's (2.17) is tense and cold. Jesus, Mary, and Joseph, like the families we find centuries later in Dobson's canvas (2.12) and then again in Norman Rockwell's *Freedom from Want* (2.14), are bound not only in time, but beyond it, and their earthly harmony is only a light-hearted reflection of their heavenly place.

A tiny image like this one shows the major theme of Renaissance family portraiture which is played over again and again with dozens of variations: the theme of the family as both a material and a spiritual bond. The inclusion by the painter of numerous material objects pitches the theme one way; a focus on facial expression and "body language" pitches it the other. This counterpoint between things and inner states is elaborately played out in Terborch's portrait of the *De Liedekercke* (2.18) and is repeated by countless painters in numerous portraits. In this view of a mother, father, and son, the faces at first seem to resist our invasion. At the back of the canvas is a family crest which defines this group by

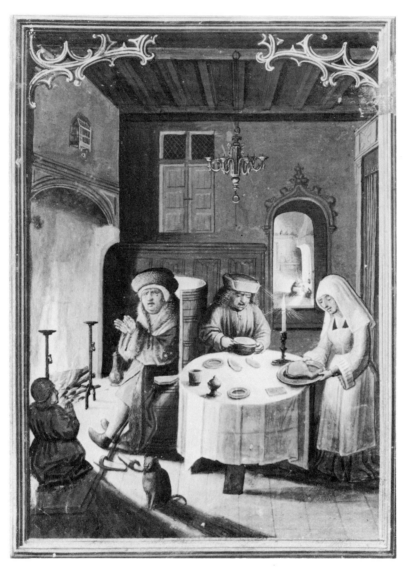

4.5 A page from the Da Costa Book of Hours,
fifteenth century
(Pierpont Morgan Library)

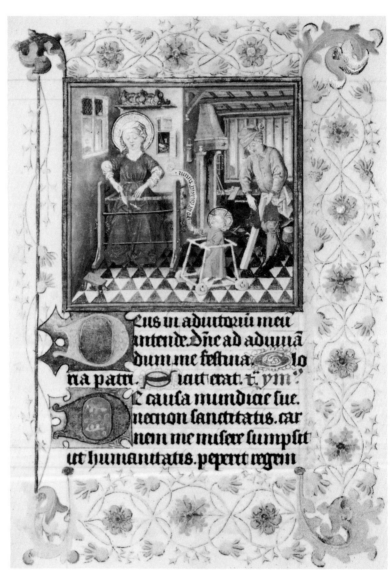

4.6 A page from the Cleves Book of Hours,
fifteenth century
(Pierpont Morgan Library)

lineage. We might easily dismiss the portrait as just another proof of pedigree. But if we look more closely we see that the portrait contains a subplot carried by the position of bodies and the reach of hands. The parents sit, while the son stands; the parents' heads are covered, the boy's is bare. Father and mother are slightly turned toward each other, but the father pivots away from the boy and the son's posture is complementary to the mother's. This hint of a special tie between them is enhanced by their hands. The mother reaches across her husband's chest and seems to be slipping a golden watch into her son's cupped hand. The transaction proceeds without the father's notice; it may show the passing on from mother to son of a particular family heirloom—perhaps from *her* family, not her husband's—while it may also symbolize, as watches inevitably do, the passage of time, the flow of property and of name, from one generation to the next. We are not sure what negotiations the painting actually shows—was it perhaps meant to be a visual document of sorts like the Arnolfini?— but we are certain that it shows us the figure this family wanted to cut, giving us a glimpse not only of its name— symbolized in the crest—but of its attitudes and behavior, the father austere, the mother prudent, the son shy, delicate, more light hearted.

The ability of formal portraiture to depict character seems to have been of particular appeal to the first photographers. Marcus Aurelius Root, the leading American daguerreotypist, advises his colleagues in 1854 to acknowledge the splendors of the human face, which "is the most perfect of all mediums of expression; the medium, too, for expressing that intelligence and affection whereon rests man's claim to be 'made in the image of God.' . . ." A portrait, "how-

ever skilfully finished its manifold accessories, is worse than worthless if the pictured faces do not show the *soul* of the original. . . ."[5] Photographs must, in other words, be about personal worth and dignity—qualities that are essential themes in Renaissance portraiture. Dickens, writing a year earlier, expresses the same convictions in a lighter vein when he describes the visit to a photographer's studio of "Dr. Sword" and his wife, both of whom are eager to act out the scenario dictated by prevailing taste—and by the cameraman:

> The lady was placed on a chair before the camera, though at some distance from it. The gentleman leaned over the back of the chair; symbolically to express the inclination that he had towards his wife: he was her leaning tower, he was her oak and she the nymph who sat secure under his shade. Under the point of the gentleman's sword, the Pilgrim's Progress by John Bunyan was placed to prop it up. . . .[6]

The "tower," the "nymph," and the "sword" highlight the Renaissance quality of the scene; what Dickens wants to stress in these allusions is moral tone: the photograph is to be a study in duty and decorum.

The scene that Dickens writes about humorously is realized in earnest in countless studio portraits in which we identify man and woman as husband and wife on no stronger evidence than their poses. Sometimes the woman sits and the man stands, as in the portrait of the Brussels couple we looked at earlier (3.19) or the Irish couple we see here (4.7); sometimes the woman stands, as in the portraits of the Indiana couple (3.20) and the German couple (4.8), in which we see the woman holding a small volume which judging from its binding must be a Bible or a prayer book.

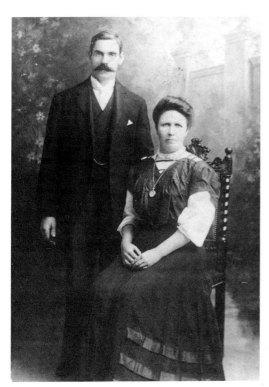

4.7 Couple, Ireland, *ca.* 1900-5
(Courtesy of the Kiernan family)

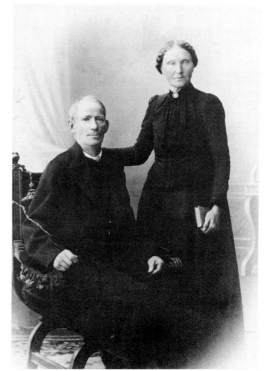

4.8 Couple, Hildesheim, Germany,
early 1900s
(Author's collection)

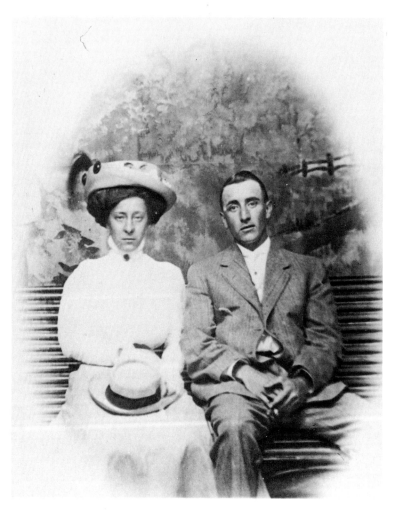

4.9 Man and woman, early twentieth century
(Author's collection)

All of these images, made within twenty years of each other, seem in some way to follow Root's "Hints Upon Sitting," in which he advises that "If in the same picture two persons are to be portrayed . . . they should be represented . . . as if a conversation was going on [p. 107]." As in Dickens's account, what matters to Root is not so much the ties that bind the figures in the photograph as the impression they should convey of mutual respect and courtesy, "the persons . . . gently bending towards each other or . . . leaning familiarly. . . ." The force of the convention, of course, extends to all sorts of pairs—to siblings and to cousins, to adults as well as to children, even to friends—wherever loyalty and community are appropriate evocations. Without the convention and without the physical signs it uses, we lack essential clues for reading the photograph. The studio shot of the man and woman sitting on a bench in front of a painted grove (4.9) is charged with emotion—the woman's scowl, the man's flaccid face, his sloppy coat and careless knees—but we cannot ascribe it to any specific tie between them. The photograph may be true to life—to incompatible temperaments, to long betrothals, to any number of realities that might have made this pair have their picture taken—but it cannot tell us what these two were to each other because it evades the convention it is meant to obey and offers no alternatives.

All of the studio portraits we have been looking at were made in the form of *cartes-de-visites,* a paper picture mounted on a heavy piece of cardboard which could be sent through the mail or distributed as a calling card. The *carte* was the invention of the Frenchman Disderi, and its development in 1859 spurred the fashion among the rich and the modest alike for photographic portraiture. Set against the dramatic land-

scapes and elegant appointments of the cameraman's studio, ordinary men and women could cut noble figures regardless of their actual lives: and parents could disguise themselves as courting couples simply by leaving their children out of the picture. Children, in turn, could be posed in adultlike attitudes, a habit that gives a haunting precocity to most of the boys and girls we see in Victorian photographs: they are children perceived as miniaturized courtiers, the "little Lord Fauntleroys" and "little princesses" we read of in the novels of Frances Burnett. Prior to the development of candid photography in the 1880s, few photographs release children from stiff attitudes or allow them to assume relaxed poses.

The most easily recognized family photograph—and the most popular—is of course the one that shows parents and children together. Photographers obviously had well-established traditions of portrait painting to draw on. But during the early days of the medium few photographers expressed any opinions about how families should be portrayed. Root only advises that "the arrangement of family groups should, save in exceptional cases, be surrendered wholly to the judgement of the intelligent and skillful artist."

And yet, from the start, photographers were always making decisions about families: who was to sit where, who was to hold which child, who was to lean toward whom. Until the availability in the early twentieth century of the reflex timer, an attachment made only for more expensive folding models, which would allow a family member to set the device, and then step into the picture himself, families as a rule could pose in their full complement only before someone who was not going to be included. And the popularity of photographs of mothers and children shows how often in the history of

photography, even into our own day, men have taken the family pictures, or else, for some other reason, have been absent from them. Yet before we jump to any conclusions on the basis of photographs about the history of family roles and family structure, we must also acknowledge the tradition of family portraiture which we saw in Titian (2.22) and Holbein (2.23), which promotes mothers and children or siblings together as appealing family subjects and excludes fathers. We can deduce very little sociological evidence from the groupings we find in family photography.

We can more easily generalize about purely abstract aspects of composition. Profiles, for instance, are seldom used in family photographs because entire faces show family resemblances more fully. Even large groups of kin usually break down into smaller clusters of twos and threes as in the Campbell photograph (1.4) we looked at earlier, and line-ups (4.10) like the one taken at a wedding are featured only at impersonal gatherings of the clan, at which the quantity of persons assembled is of greater significance than their individual personalities and loyalties. The layout of formal portraits often appears to describe a plane: we see triangles with bases and apexes, configurations with points and angles which make us ask who in the family is at the top, who is subordinate, who is out of line, who has power, who submits, and who defies. The lines in a formal portrait are almost always clearly drawn; they move from parent to child, from child to parent, along lines of blood and property, of dependence and duty, which the family follows from one generation to the next. Relationships appear as sets of propositions. Love, contempt, and envy are all withheld from our view: we see only arms that hold and support, bodies that lean and shield. Such pat-

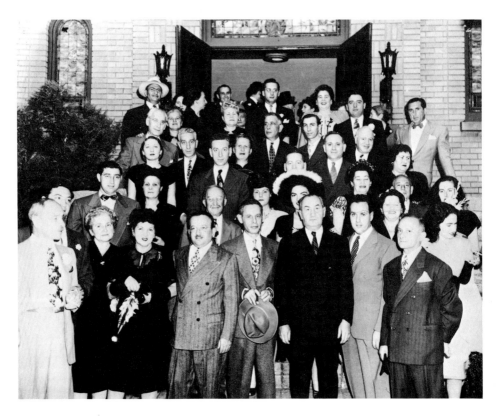

4.10 Wedding party, early 1950s
(Courtesy of Jean Innerfield)

terns compel us to interpret the family by the standards of politics, not of passion; and of states, as of the families we see in formal photography, we ask not how they feel, but how they function and for how long they can endure.

Formal photographs stand against emotion. They permit us to look *at* the family, not *into* it, and present us at best with a few ethical principles about how parents and children ought to look. This refusal to yield any quarter on intimacy derives from the same traditions of personal conduct that are exemplified in Renaissance portraiture (and other Renaissance sources) and find their most conversational and accessible expression in Baldassare Castiglione's *The Book of the Courtier* (1516; English trans. 1561). Castiglione, himself a party to the life he idealizes, offers us a dialogue on love and beauty, but his book is also a discourse on etiquette and a manual of what a modern sociologist would call "the presentation of self in everyday life." To Castiglione, the essence of human relations is not passion but self-control and the highest distinction is "to eschew as much as a man may, and as a sharp and daungerous rock, Affectation . . . and . . . to use in every thyng a certain Reckelesness [graciousness] to cover art withall, and seeme whatsoever he doth and sayeth to do it wythout pain, and (as it were) not mynding it."[7] The person of value, according to Castiglione, is he who guards himself against compromise by masking effort and feeling in studied neutrality. Such blandness was sound advice in Castiglione's circle of professional civil servants for whom self-disclosure might prove politically fatal: but his rules of conduct quickly became a guide to etiquette for the newly rich Continental and English middle classes who needed to learn how to behave. Castiglione guided not only manners but art.

His notion of willed serenity is reflected in the grace of many courtiers depicted by Bronzino, Titian, and later, Van Dyck.

Formal photography is more than three hundred years and many cultural revolutions removed from Castiglione, and yet we find that many of his assumptions about admirable conduct are echoed by writers on photographic portraiture and are incorporated into the pictures themselves. In taking portraits, Henry Snelling wrote in 1849,

> the conformation of the sitter should be minutely studied to enable you to place her or him in a position the most graceful and easy to be obtained. The eyes should be fixed on some object a little above the camera, and to one side, but never into, or on the instrument, as some direct; the latter generally gives a fixed, silly, staring, scowling, or painful expression to the face.[8]

Snelling, like Castiglione, admires reserve and urges the avoidance of emotional display. Just as the courtier must conceal care or strain, so the formal photograph must avoid being a visual confessional, and must shield subject, viewer, and photographer alike from passionate engagement. Only blandness will do—like the "how d'ye do's" at a tea party which the polite conversationalist never answers with a clinical reply. Facial expressiveness seems to Snelling to be the stuff of misfits, of nuisances, and of the insane; and in his sense that emotional display is a form of pathology he is by no means alone. Some thirty years later, Darwin makes a comparable and even more emphatic comment on the subject in his essay, *The Expression of the Emotions in Man and Animals*, a monograph vividly illustrated with photographs by O. G.

Rejlander. Only "the insane," Darwin points out, "notoriously give way to all their emotions with little or no restraint."⁹ Darwin's remarks vindicate the retoucher's function, for if the scowls and grimaces that fill his essay are the marks of beasts and lunatics, then the retoucher serves not only personal vanity but the dictates of culture at large. And many of these dictates are rooted in the Renaissance. "See the Venus of Medici,"¹⁰ advises a retoucher's handbook. But not only the cosmeticians of the photographic process followed this advice: photographers, too, including David Octavius Hill, Julia Margaret Cameron, and Rejlander himself set out to imitate specific paintings by Raphael, Caravaggio, Tintoretto, and Titian.

In family photography allusions to earlier times are far more diffuse. We have seen them in the painted backgrounds of photographic studios. But they also show themselves in the poses and attitudes that families assume before the camera. In the photograph of the Eastern European family (4.11) the father is posed in an attitude of princely authority and his brood is camped around him like so many retainers. We have seen this "pattern" of kind before. It shapes Holbein's portrait of Sir Thomas More (2.11); it is the pattern Dickens mimics in his description of Dr. Sword; and it is the pattern European photographers traveling to the Far East grafted onto alien cultures, so that the Cantonese shopkeeper (4.12) appears to us like any workaday, Occidental merchant. The Renaissance model undergoes all kinds of transformations and we can only guess what version of it inspired a small-town cameraman in Russia or Poland to pose this particular family this way.

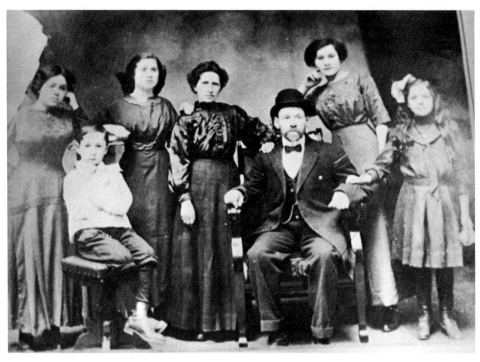

4.11 Family, Eastern Europe, early 1900s
(Courtesy of Jean Shapiro)

4.12 M. Miller, *Cantonese Shopkeeper and Family*
(Royal Asiatic Society of London)

We do know that Western Europe taught the world how to take pictures and that Eastern European studios assumed such names as "Raphael" and "Rembrandt."[11] With these diffuse influences in mind, the photographer might simply have said, "Like this," giving each family member a clue about how to stand, how to sit, how to flex an arm or prop a head. And "like that" they stood (4.11), straining toward their own fantasies of grace, the man, so stocky next to those towering women, the women, too large to look convincingly subservient, the little girl, confused by the occasion. And we know how this family feels: it is the way we all feel—at once submissive, proud, and self-conscious—when we smooth our hair, set our faces in pleasing lines, straighten up, and yield to the photographic moment. The Renaissance sources of family photography have long since been buried and we no longer think of resembling a portrait by Holbein. We aspire instead, in our formal photographs, to look like our contemporary symbols of power and authority: the first families of politics and corporate business which we see almost daily in press releases. In our formal family photographs we still endeavor to look cohesive, strong, and gracious, but we have forgotten the ancient imperatives that shape our wishes.

At the same time, we have an alternative to formality: for us family photography can also be candid shots which include all the peevishness, boredom, and caprice that disturbed Henry Snelling in 1849. Candid photography, usually regarded as the result of the box camera, makes few demands of time and place; and it embraces all human possibilities of pose and expression. Because it generally requires so little discipline both from the cameraman and from the subject, it is the medium of the amateur; because it is so generous a me-

dium, it has today been rediscovered by professionals. Candid photography facilitates a view of the family which we already know from the bawdy canvases of Bruegel and Jan Steen, from Hogarth, Rowlandson, and Daumier; from the tender scenes of Mass, Chardin, Renoir, and Mary Cassatt; from the tragedies of Hunt, Egg, and van Gogh: the view of the family as appetite, impulse, passion, and violence. The candid shot— whose very name implies honesty, spontaneity, and artlessness—takes no more total view of its subject than does formal photography, but arises out of different conditions.

In candid photography anything can happen: the term itself makes no exclusions and no particular promises. Candid photography can be as posed as the 1950s shot of the family in its living room (3.8); as arch as Emmet Gowin's photograph of his family on their lawn (4.13); as accidental as the glimpse of a father and his baby (4.14). Whatever the content of the candid shot, it is always about bodies in transit, about gestures that we know can have been held for only a few moments. While formal photography is about condition and being, candid photography is about process and circumstance. Although candid photography came to be taken by such professional art photographers as Lartique in France and Paul Martin in England, we usually associate it with amateurs, because the box camera, once produced, quickly found its way into the hands of ordinary men and women who, without special training or sensitivity, could click at their families, their friends, their pets, and their homes. Because we know that candid shots are often taken without clear moral or artistic intention, we look at them differently from the way we look at formal photographs. Of formal pictures we need never ask, "Why was this picture taken?" "Why was this picture

4.13 Emmet Gowin, *Family, Danville, Virginia, 1970*
(From Emmet Gowin Photographs *by Emmet Gowin.*
Copyright © 1976 by Emmet Gowin.
Reprinted by permission of Alfred A. Knopf, Inc.)

4.14 Father and son, 1960
(Courtesy of the Kiernan family)

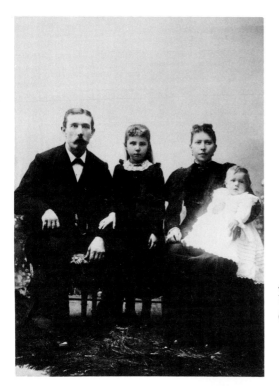

4.15 Family, late nineteenth century, Union Hill, New Jersey *(Author's collection)*

4.16 Southworth and Hawes, Family, mid-nineteenth century *(International Museum of Photography at George Eastman House)*

kept?" The photograph itself tells us: it was taken to immortalize a rite, an event, a possession, a family relationship. Of candid photographs, we must almost always ask—and the answers are often far from clear. Candid photography often gives us awkward, embarrassing, and comic views which may then cast doubt upon the motives of those who kept them. If, as Marshall McLuhan once said, the age of photography is the age of psychoanalysis, then formal photography belongs to Jung and candid to Freud.

But the first candid photographs did not come from the box camera: they are formal portraits misfired. The subtle differences between two very similar studio portraits makes this clear. The one, from a New Jersey studio, is a fine example of impeccable camerawork (4.15). Every hair and fold of cloth is in place and all the eyes, even the baby's, look in unison to the side as if Henry Snelling himself had been in charge. The second (4.16) comes from the Boston studio of Southworth and Hawes. In layout it is almost a double of the first, but chance has unsettled the composition. Glances diverge, the baby and the child at the middle have moved; the beads are off center; the mother's collar is folded over and her chin sags. Clearly the picture has failed the standards set for it: innocent gestures have frustrated illusion. And yet the photograph leaves us unsettled: we want to return to it for another look. The first photograph, in its perfection, raises no questions; the second, with the flaws of candid photography, answers none.

Like slips of the tongue, candid photography speaks to us of hidden meanings, of intentions we did not know we had, of emotions we had not recognized. The middle-aged couple

leaving the church after the wedding (4.17) thought that they were having a formal picture taken. But the shot misfired: it became candid. Instead of being a commonplace—the proud parents beaming as they leave the church—it is a paradox: man, affable, woman, more restrained, together and yet poles apart. We look and wonder. The photograph upsets any pious convictions we might have had about parents and about weddings. But it seems also to reveal an uncomfortable and embarrassing truth: that after weddings, parents are often confused; that the wedding of a child may loosen the ties which once welded mother and father together; and that our chance gestures, our accidental faces, may betray us, even in our moments of joy.

Candid photography, with its ability to accommodate almost anything that passes in front of the camera, transfers the task of finding meaning from the photographer to the viewer: we can click, click, click at a family picnic or a wedding party and decide later, after we've seen what "came out," which of our shots have meaning and which don't. In judging candid photographs we do not consider so much whether the people in them "look good"—and in candid photography they often do not—but whether the picture, like a signed confession or an hour of psychoanalysis, has laid bare some critical truth to which we can assent. Comedy, irony, and paradox seem to be the very stuff of candid photography; but these qualities thrive in the candid picture not because they need fast film and the box camera to find expression, not because they have somehow become statistically more prevalent since the 1880s, but because these qualities are enhanced by the very flaws and blemishes that fall so easily, without necessary design or motive, into the candid camera's eye.

4.17 Parents of the bride, 1957
(Courtesy of the Kiernan family)

4.18 Parents and son, 1935
(Author's collection)

A great deal of candid photography, like the shot of the family trio (4.18), mimics the style of formal portraits. Just as the professional who posed the Eastern European family (4.11) was drawing on some commonplaces he knew of authority and dignity, whoever took this shot had some notion of how a family ought to look: the father, authoritative, the mother, tender, the child, protected.

But here, as in other formal photographs gone wrong, reality has broken through illusion. The father's grip is strong and sure, but the child's body and the man's back seem to be moving in opposite directions. The father strains out of proportion to the child's weight, and the child avoids leaning on the father's chest, as if uncertain whether the grip is supportive or hostile. The mother's hand seems tacked on, as if she does not want to touch either man or child. While the man is looking at the camera, and the child beyond it, the woman seems to be looking into herself, giving her smile not to the child or the husband but to some private thought which she is compelled to visit, even here, in this supposedly shared moment. The photograph, which owes so much to formal portraiture, speaks with a different accent. It is not like the Terborch or the Dobson paintings about time and mortality, or about family and destiny, but is instead about feeling, which, like the father's back or the mother's smile, can undermine as well as sustain our view of the family as secure and dependable.

Our reading of candid photographs thus leads us easily into a vocabulary of psychoanalysis. We have no alternative, since candid pictures show us personalities and behavior: the stray strands of hair and sudden twitches that flit before the camera. In most of our candid family photographs

we can still hear the claims of formality as we do in the picture of the Eastern European family. And we can follow them. We can ask of that particular shot, who is central and who is peripheral: the child? the mother? We can also consider the Romantic implications of the pastoral setting—an unnamed park—and the quality and cut of the clothes—fairly stylish but not opulent, a distinctive detail in the post-Depression world. But if we look at this photograph as a sociological document, we shall not have seen enough of it. We shall not have seen enough of the faces and bodies, the muscles and nerves that make candid photography so intimate, so compelling, and, often, so disturbing.

Candid photographs take us into the realm of abstraction, of subconsciousness, and like inkblots or obscure poems, tax the sensibilities of those who take and look at them. Candid photography is full of fragments and distortions, like the legs and cut-off face we see in the shot of the father and baby (4.14). But we cherish them, and read into them far more than is left out: the pride of the parent, the joy of having a baby at all who can be made to loom so large and strong. Candid photography is not about the whole of our experience but about pieces of it which, like an artist's sketch, serve us as an emblem. When the Nebraska settlers had themselves photographed in front of their homestead with all their furnishings (2.7), cow and all, the photograph was meant to tell us of their deeds and their possessions, and to explain where they belonged in the world of work and of objects. Emmet Gowin's shot of his family in Danville (4.13) avoids such commonplaces: here there is no work, no structure, no unity, only a watermelon symmetrically split down the middle and people of different ages scattered about in various states of

disarray. Using at once many of the effects available to candid photography, Gowin has replaced external clues with inner ones; rather than imply a story, as Degas does in his portrait of the Bellelli, he gives us an impression.

Candid photography, as Gowin's photograph does, allows us to *see;* it can free us from rooms and houses, from rites and ceremonies, from all the places and events that fix the family in time and in society, to focus, instead, on the silences between us. But the feelings—of heat, of torpor, of separateness—which characterize his kin also prevent them from affecting the world around them, and from touching each other.

Gowin's view of the family as a lonely gathering of solitary people is today regarded as a late twentieth-century commonplace which finds ample expression in the literature and social criticism of our day: in the work of Ionesco, Arthur Miller, Albee, of R. D. Laing and Christopher Lasch, to mention only a few of the more significant names. But, despite them, we continue to take family photographs and even relish their animated form in home movies, television "sitcoms," and commercials. The disorderly conduct which the candid camera immortalizes, even when it shows us fathers and mothers, cousins and siblings, increasingly obscures who's who, and what's where. Place, time, and role have yielded, in family photography, to more neutral and general studies of "relationships" which may or may not be those of blood, of household, and of property. Parents and children who were once posed together like monarchs and subjects can now be shot nude, exposed not only to the world's curiosity, but to each other. This newer attitude has its shock value: like so many other contemporary habits, it assaults ancient taboos

and forces us to reassess our convictions. The focus in candid photography on people rather than roles has freed us from guilt: we would rather see a man serving the hamburgers to his mother-in-law (4.19) than stiffly holding his child (2.4). The humor, paradox, and irony which came into formal family photography by accident have become the staples of candid photography, and the lightness of candid photography has in turn loosened the primness of formal pictures: the affable smile on the young man's face (4.20) would have been inadmissible in his parents' day; and his grandchildren, if they marry at all, will probably have their wedding pictures taken in a rose garden or under some trees.

These mutual influences become clear when we compare the candid photograph taken a few years ago by a professional photographer (4.21) and the formal photograph of the mother and son (3.28) we looked at earlier. The older photograph shows full faces and we see the adult standing over the child in the age-old ratio of strength and vulnerability. The bodies are apart, each intact and yet linked by the mother's hand and the powerful resemblance we can observe between them.

In the contemporary photograph we hardly see gender and cannot easily distinguish role: we are oblivious to resemblances and see only a child's hug and a man's clasp. We need the photographer's assurances that we are indeed looking at parent and child. Because man and child are almost faceless, anyone can lay claim to them; and because they are faceless we can all put our features in their place. The photograph is useless as a family record; yet as a study in trust and need— thus as metaphor—it is stark and powerful.

Trust and need, however, take us far beyond our personal and our domestic experiences. They are also the emo-

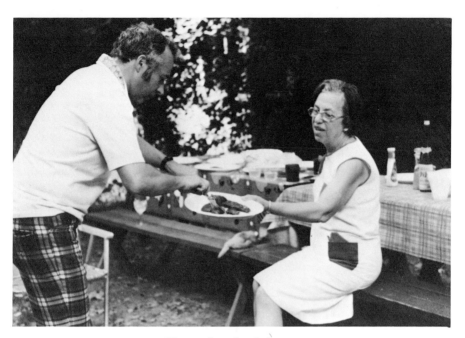

4.19 Man and mother-in-law, 1970s
(Courtesy of the Nelson family)

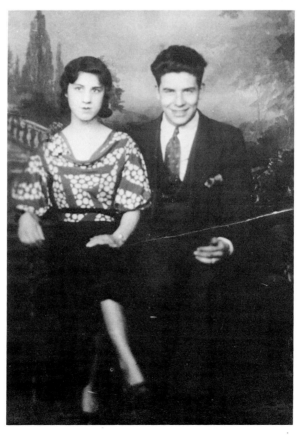

4.20 Husband and wife, 1930s
(Courtesy of the Kiernan family)

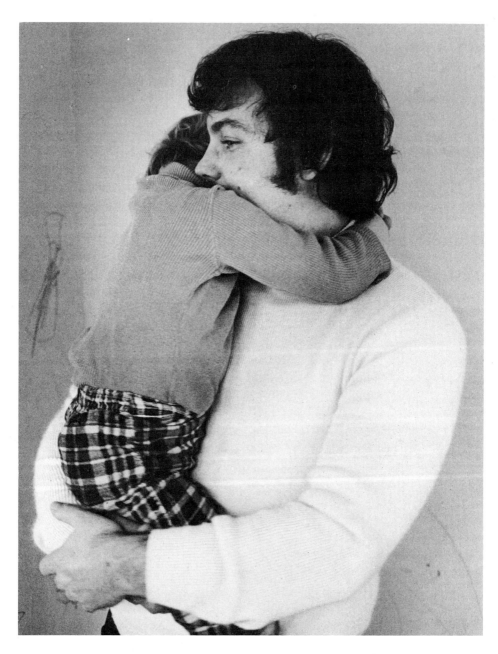

4.21 Father and daughter, 1970s
(Copyright © 1976 by Jean Shapiro)

tions of religion and politics. Family photographs serve our culture not only as personal records but as lures to our love and confidence: in our leaders, our entertainers, our demagogues, and our suppliers of goods and services. Family photographs are also a rhetorical device which our society uses to inspire and to coerce, because these photographs look back at us and touch our values, our beliefs, and our frailties.

5

The Family Image

Whether in boxes or in frames, in wallets and lockets, miniaturized or blown up larger than life, our family photographs make their own journeys through time and space. They show us what clothes were worn, what rooms were lived in, what places were visited; but in all their variety they record only single moments, when the pictures themselves were taken. Out of such winks at experience, we make lyric, narrative, sermon, and prophecy: about our passions, our experiences, our failures, our illusions. We make known our interpretations not only in the way we read faces and bodies—in the voices and states we attribute to them—but in how we display the photographs themselves. The baby picture on a mother's dresser; the vacation snapshots on a father's health-club locker door, or office desk; the parents' portrait on their grown child's night table: each of these is the reminder of a powerful bond which we place, tactically, at whatever spot in the course of our daily business we can stop for a moment to touch its pulse with our gaze. Such pictures trigger communion between us and our emotions. They look into us, as much as we look at them. But we can also use our

family photographs in far more complex ways; a picture hidden may reveal as much love as one displayed, and the person who flaunts his family photographs often uses them as small artillery in his own battles with self-esteem, success, and personal fulfillment. The disappointed father puts the formal photograph of his niece as blushing bride on the mantelpiece, not because she is so dear to him, but as a lesson to his daughters who, to his grief, have not wed at all. The elderly woman, solitary in her memories of lost possibilities, fills her house with pictures of her children and grandchildren. Daily she prays at mass for her dead husband's soul. But she hides his photograph in the linen closet as a way of settling grievances with his body: in death he abandoned her and now his face is buried among the bedclothes.

Themes of growth, decline, and even renewal seem to emerge from our family photographs because they are part of the very chronology of our lives. The movement from birth to maturity to expansion into another generation of children and in-laws is easy to document because it is part of our biology. Such an order can overlook much of our experience. Family photographs, so generous with views of darling babies and loving couples, do not show grades failed, jobs lost, opportunities missed; and the divorced spouse can easily be torn up or cut out of a family group. The renegade, the wastrel, the outlaw are not pictured in their extremities. They are simply not pictured at all. The family pictures we like best are poignant—and optimistic.

In recent years, inspired in part by political movements of national liberation, and in no small measure by Alex Haley's *Roots,* many of us have sought reunion with our forebears. Family photographs have often been our point of

contact. If our real ancestors have proved to be missing persons in the history of war, of persecution, and of social change, we have even been willing to settle for surrogates: the careworn peddlers and tanned peasants who appear the way our forefathers must have looked. The current interest in the muddy villages of Eastern Europe and rural America reflects a concern with origins and sources. But it also tells on us who are so proud of poverty and squalor, of suffering and survival. It tells of our need to vindicate our lives, of our longing to read them as the fulfillment of our ancestors' dreams. Their deprivations highlight our abundance, their candor sets off our sophistication, their pain justifies our pleasure. Those of us whose forebears were rich and proud have been less zealous in asserting our origins. Times are hard, these days, and if we say too much about ancestral prestige our own successes may pale by comparison. There are fashions in ancestry as much as there are fashions in cars and clothes: right now many of us like our ancestors poor because they do so much for our own image.

Family photography—a source of so many vital statistics—is a cue to family passion, and like that passion it can be synthesized. Hitler and Stalin had themselves photographed kissing babies and taking bouquets of flowers from young children, creating illusions of family that are the commonplaces of politics in even the most beneficent democracies. Both demons and men of good will have claimed to be "the fathers of their country." Just as in contemporary jargon warm feelings accrue to whomever and whatever can attract the prefix "family"—as in "family style," "family size," family man," though we do not as yet speak of "family woman"— empathy and a sense of community can be triggered by a fam-

ily photograph even if we do not know at whose kin we are looking. These powerful and generalized emotions include a drive toward self-sacrifice, and also courage and zeal; they closely resemble the "limitless, unbounded, as it were 'oceanic sensations' " which Freud associated with religion, and which he described as "a feeling of an indissoluble bond, of being one with the eternal world."[12] These emotions are released in us whenever we see any family photograph, even if it is of strangers, or of persons to whom we are otherwise indifferent. We read "family" as a metaphor for all of humanity, beyond race, ideology, and history, and in doing so concede a whole range of ethical assumptions. The continued appeal of Edward Steichen's *Family of Man* exhibit which first appeared in 1955 is evidence enough that photographs of families symbolize ideals of universal brotherhood and understanding. We all bear witness to these ideals in our everyday lives. We warm instantly to the most callow bureaucrat who has a picture of his children before him on his desk because the photograph places a stranger in a context of care, need, and love. And our charity and altruism can easily be tapped by photographs of destitute families because in them we discover our own vulnerability.

The values that family photographs invoke touch not only religion and ethics but sociology and politics. To say that a person is a "family man" and to demonstrate his status through a family photograph, showing him with his wife and children, is not only to imply that he is a person who obeys the claims of blood, of continuity, of tradition, but to aver that he is stable, responsible, altruistic, an ideal candidate for any position that calls for compassion, a sense of responsibility, and the ability to control others. Family photographs are

part of any political campaign because they take us directly into the candidate's domestic life and show us his ostensible political competence, in miniature. Although history has often given our faith the lie, we like to think that the good provider at home will also be a good provider on a grand—national—scale and press agents see to it that our faith is served in the family photographs of their clients. Of family, we might well say as did Dr. Johnson of patriotism: it is the last refuge of a scoundrel. For politics as for public relations, this is a crucial insight.

But Madison Avenue did not discover the power of images; the association of photography with politics is much older. Napoleon III's visit to Disderi's Paris studio in 1859 set off the rage in France for the *carte* portraits which the photographer had invented; and the images of royal families became popular items for loving and curious subjects to collect and exhibit throughout Prussia, Austria, and Russia. In England Queen Victoria was not only an avid patron of photography—founding a Royal Society for its stimulation—but a zealous model. Before the camera she had only one scruple, that she be pictured only as wife or mother. Ingenuous as this scruple might appear, it signaled a valuable political insight. In a vast empire of differing races and cultures, divided into the two nations of the rich and the poor, the impression she wanted most to make—as mother of nine, and then widow of one—was the one which stood above party, creed, or class. Family, she knew as well as Dickens or Galsworthy, is blood and money: but she also understood, as does the modern press agent, that it gives an instant impression of warmth and tenderness.

This sudden burst of affection is stimulated in us not

only for public servants but for rock stars, athletes, actors, and criminals. In their pursuit of art, of fantasy, of evil, all of these performers enter the frenzies of music, movement, and death on our behalf. The photographs of an entertainer having her hair put into curlers by her daughter, of an Academy Award winner taking a shower with his wife, of an assassin having Thanksgiving Dinner with his nieces and nephews are part of the relentless public relations effort to make the ambitious, the mean, and the perverse lovable; and the world of Big Time Fun, Games, and Crime is so remote from most of us that we would quickly lose interest in our stars if we could not somehow bring them closer to us.

Family photographs, which take us beyond merit or notoriety into human ordinariness, are often the means by which this illusion of closeness can be brought about. For this reason family photographs are often simulated in advertising. Telephone sales are boosted by the picture of an elderly man who is cheered up by a phone call. This is Grandpa, pulled out of geriatric doldrums by the voice of his granddaughter. The picture immediately turns the phone, for which we all pay a pretty penny, into a social service which comforts the lonely and strengthens family ties. An airline promotes its new rates by showing a man, woman, and two children walking briskly to the airport. While we read the caption which describes the latest "family plan," we are asked to imagine that these eager people are the family whose closeness has just been enhanced by the airline company. The picture convinces us, as does the telephone ad, that the airline's chief motive is domestic felicity; and that if we are indeed the good parents and spouses we want to be, we shall

promptly purchase this particular travel package for our families. We expect, of course, that goods that are manufactured for domestic consumption—prepared foods, laundry soaps, paper diapers, even cameras—should be promoted by means of a family appeal. When products that have no special function in our lives as parents and children, husbands and wives, are promoted by using simulated family photographs, we begin to see the extent to which our society has transformed "family" from a particular kind of institution to a cluster of titillations. Where once we spoke of meeting family duty and obligation, we now speak of providing "family fun."

Photographs of families serve not only to make the powerful accessible, the evil charming, the complex simple: they also bring remote and monumental terrors to our consciousness. Countless tragedies of modern history stay with us long after the statistics have faded. The Warsaw Ghetto is the little boy and his mother who head a group of doomed captives; mercury poisoning is Eugene Smith's photograph of a mother holding the gnarled body of her daughter; war and hunger are the dying mothers and tiny swollen skeletons of Biafra, India, Ethiopia, Vietnam, and Cambodia; and a thousand days drip down Jackie's pink suit. None of these photographs was taken to record the lives of kin; they were taken to document events. They touch us because they interpret history in domestic terms, as tragedy which happens to families.

In the photographs we take to record our own lives we are far more circumspect about disease, pain, and death. Elizabeth Kübler-Ross's book, *To Live Until We Say Goodbye,* contains a photographic study of a little girl with a brain tumor dying slowly in the daily company of her mother and her

brother. In *Gramp,* Mark and Dan Jury have recorded the deterioration and death of their grandfather. Dozens of picture books that advocate natural childbirth and breast-feeding show mothers giving life and nurturance. But these photographs of blood, pain, and transfiguration were taken to illustrate their authors' insights and values; they were not the casual and slow accumulation of photographs which we take and store to record our family experience.

All our family photographs are stalked by death: but they usually show it symbolically. The custom of photographing the dead was briefly followed in the United States during the 1850s in a decade of unusually virulent epidemics. But such a custom, rather than remind us of a life we would like to commemorate, impresses upon us the end we would like to forget. The photograph taken before 1914 (5.1) transforms the earlier convention into a more elusive statement of fact. The dead baby smiles in a cheery insert above his grieving parents.

Pictures of the dead are always with us but we see the dead as alive. Montages of family photographs like the one put together by a professional photographer of her own family (5.2) are very popular nowadays; and we can all do our own given the availability of pictures and a suitable frame. Such an "arrangement" confronts us with an overwhelming number of eyes, and makes the viewer, who may well be included in the paste-up, all too aware of his biological roots. The emotional impact of so many encounters is both powerful and confusing. The living and the dead congregate; parents appear younger than their children; and all these faces in the midst of their respective lives are innocent of the destinies which will link them one to the other. The great pulls

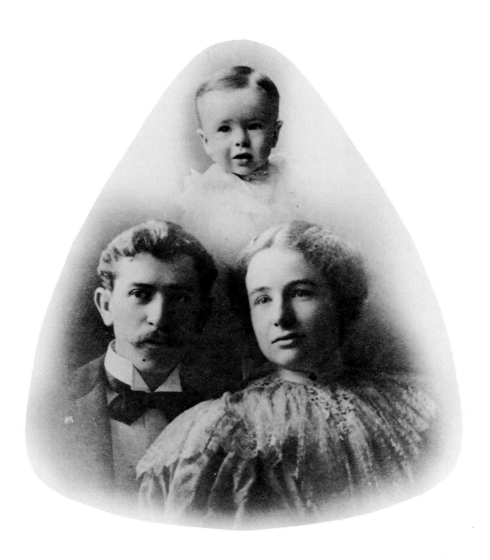

5.1 Parents and child, early twentieth century
(Author's collection)

5.2 Montage, made in the 1970s
(Courtesy of Jean Shapiro)

of history, cause and effect, are obscured: and the arrangement which engages our emotions in a rush of curiosity, nostalgia, guilt, sorrow, love, and anticipation dissolves the passage of time into a series of parallel moments. The arrangement neither interprets nor represents life for us. As never really happens, it is all happening here at once.

The current fad for creating such montages extends and complicates a far older pictorial convention. The living and the dead have been meeting for a long time; one of their most haunting encounters takes place in Georges de la Tour's painting of Mary Magdalene (5.3). With the skull in her lap and the flickering candle highlighting her sensuous body, she represents the vanity of human wishes, the same theme that troubles Hamlet when he finds the skull of "poor Yorick" in the cemetery. In photographs, the living display the pictures of their dead and bring about their resurrection. In the photograph of the two little girls (5.4), a framed picture of another generation reminds us of the passage of time. We do not know who the tiny photographed figures are but the photographer must have considered them of consequence to the children, since the girls are posed side by side at the same angle to each other as the adults in the frame behind them: the parallel lines impress comparisons upon us. The delicate vivacity of the children stands against the pictured stillness. The entire composition, like other images-within-images, establishes a tie between the moment photographed, and a history which preceded it. We see four pairs of eyes which have overcome time and space in order, together, to look at us. Distance has been compressed into one rectangle, the Renaissance dream of killing time has been achieved, and we see before us only an ever-dissolving present.

5.3 Georges de la Tour, *Mary Magdalene with a Nightlight,*
ca. early seventeenth century
(Musées Nationaux-Paris)

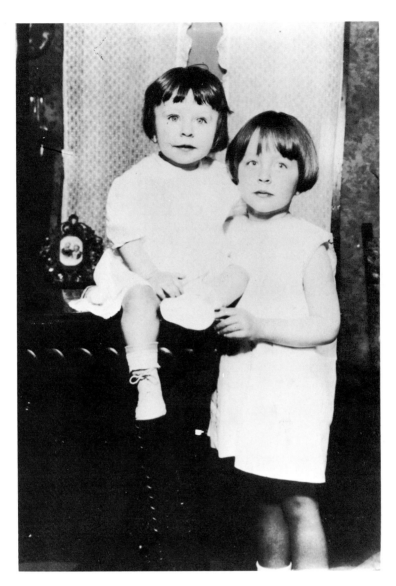

5.4 Sisters, early twentieth century
(Courtesy of Jean Innerfield)

5.5 Girl next to portrait of her deceased grandmother, 1960s
(Courtesy of Carole E. Schwartz)

In the candid photograph of a young adolescent and the hand-tinted photograph of her grandmother (5.5), two solitary figures, one in a frame, the other in a barren room, have joined forces to become a family photograph: had each been pictured alone, we would not know that they belonged to each other. A clumsy shot, in which the girl's hair ribbon peeks like rabbit ears from behind her head, and the wall thermostat obscures the symmetry of her curls, the picture nonetheless carries out its purpose: it brings together two faces, two people, two lives into a single photographic moment, and turns aloneness into continuity.

Bonds that have lived in time, and also endured beyond it, are an underlying theme in all family photographs. The dead and the dying live forever in our family photographs as long as our eyes see them; and for all the material richness of our photographs—for all the clothes, rooms, cars, and pets we see in them—it is our glance that bestows the final gift of life. To look at a photograph is to be a medium: our mere glance warms a flatness. But finally we bring to family photographs far more than our eyes. We bring all we know of what lies beyond the edges of the picture. We bring our knowledge of childhood and adulthood, and all that goes on between and beyond. We can understand the photographs even of strangers because we know that pictures of families are made and stored in the same ways that families themselves endure. Affirmation, love, need, tenderness, all these clear statements with fuzzy edges, trail in deepening shadows across our photographs as they do across our lives. We can always be sure that within each family photograph there will be some message about birth, growth, affinity, or distance. The messages

are very simple; and very complex. We examine, arrange, store, or hide our family photographs as we scrutinize, nurture, rationalize, or deny our family relations.

In a busy office, a father casts a quick glance at the snapshot of last summer's fishing trip with his son; while elsewhere, somebody's husband grins in the linen closet.

$\mathcal{N}otes$

PREFACE

The works to which I refer include Philippe Aries's *Centuries of Childhood* (translated by Robert Baldick) (New York, 1962); Van Deren Coke's *The Painter and the Photographer* (Albuquerque, N.M., 1972); Aaron Scharf's *Art and Photography* (Baltimore, 1975); Catherine Noren's *The Camera of My Family* (New York, 1976); Dorothy Gallagher's *Hannah's Daughters* (New York, 1976); Marsha Peters and Bernard Mergen's "'Doing the Rest': The Uses of Photographs in American Studies," *American Quarterly* (vol. xxix, no. 3, 1977), 280-303; Robert Akeret's *Photoanalysis* (New York, 1975); and Eastman Kodak, *Preservation of Photographs* (Rochester, 1979).

CHAPTER 2: HISTORY

1. Eli Zaretsky, *Capitalism, The Family, and Personal Life* (New York, 1976), p. 36.
2. Quoted by G. M. Trevelyan in *English Social History* (London, 1946), p. 571.

NOTES

CHAPTER 3: PLACE AND TIME

3. Quoted by Joan Evans, *The Victorians* (Cambridge, England, 1966), p. 90. From Ruskin's essay "On the Present State of Modern Art," *Works,* XIX (London, 1905), p. 200.

4. Quoted by Barbara Norfleet in *Wedding* (New York, 1979).

CHAPTER 4: FACES AND BODIES

5. *The Camera and the Pencil* [1864] (reprinted Pawlet, Vermont, 1970), p. 143. All other quotations from Root are taken from this edition.

6. Reprinted by Beaumont Newhall in *On Photography: A Source Book of Photo History* (New York, 1956), pp. 83-84.

7. (Reprinted, New York, 1967), p. 59.

8. *The History and Practice of Photography* [1849] (reprinted, New York, 1970), p. 41.

9. (New York, 1955), p. 154.

10. Quoted by Helmut Gernsheim, *The History of Photography* (New York, 1969), p. 235.

11. Lucjan Dobroszycki and Barbara Kirshenblatt-Gimblett, *Image Before My Eyes* (New York, 1977), p. 5.

12. *Civilization and Its Discontents,* trans. James Strachey (New York, 1961), pp. 11-12.

Selected Bibliography

In recent years, photography has become a new frontier for sociologists, historians, anthropologists, and art critics. As a result, my reading in preparation for writing this book took me in many directions. I read works on semiology, visual anthropology, and social psychology; on the history of women, children, cities, and labor movements; as well as books on the history of art, photography, and the family. Listed below are a few of those books I think will be of interest to the general reader. A short summary of the work appears wherever its title does not tell us enough about its contents.

ART HISTORY, PHOTOGRAPHIC HISTORY, AND THE INTERPRETATION OF THE VISUAL IMAGE

Akeret, Robert V. *Photoanalysis*. New York: Pocket Books, 1975. Dr. Akeret's patients use their own family photographs to reconstruct early experiences and learn, through their interpretations, to understand their histories.

Bell, Sir Charles. *The Anatomy and Philosophy of Expression as Connected with the Fine Arts*. Seventh edition revised. Lon-

don: George Bell and Sons, 1880. (Originally published in 1806.)

Berger, John. *Ways of Seeing*. New York: Viking Press, 1972. Berger sees seventeenth-century Dutch genre painting and portraiture as the glorification of mercantilism and links this form of art to modern advertising as the advocacy of a way of life.

Coke, Van Deren. *The Painter and the Photographer*. Albuquerque: University of New Mexico Press, 1972.

Collier, John, Jr. *Visual Anthropology: Photography as a Research Method*. New York: Holt, Rinehart and Winston, 1967.

Darwin, Charles. *The Expression of the Emotions in Man and Animals*. New York: The Philosophical Library, 1955.

Davis, Thomas L. *Shoots: A Guide to Your Family's Photographic Heritage*. Danbury, N.H.: Addison House, 1978. Davis gives advice on how to preserve, arrange, and read the photographs we often tuck away in attic baskets or dresser drawers.

Gernsheim, Helmut. *Creative Photography: Aesthetic Trends 1939 to Modern Times*. New York: Bonanza Books, 1962.

―――. *The History of Photography from the Camera Obscura to the Beginning of the Modern Era*. New York: McGraw-Hill Book Company, 1969.

Gombrich, E. H. *The Story of Art*. Thirteenth edition. New York: E. P. Dutton, 1978.

Hall, Edward T. *The Silent Language*. New York: Doubleday, 1959. An introduction to the idea that time and space are defined by culture.

Ivins, William M. *Prints and Visual Communication*. Cambridge, Mass.: The MIT Press (third printing), 1978. The

complex history of images and patterns that repeat themselves, and their impact on the imagination.

Newhall, Beaumont. *The Daguerreotype in America*. Third edition revised. New York: Dover Publications, 1976.

———. *The History of Photography from 1839 to the Present Day*. New York: Museum of Modern Art (distributed by Simon and Schuster), 1949.

——— (ed.). *On Photography: A Source Book of Photo History in Facsimile*. Watkins Glen, N.Y.: Century House, 1956.

Nochlin, Linda. *Realism*. New York: Penguin Books, 1977. (Originally published in 1971.) A survey of the aesthetic styles and concerns that flourished in Western art at the time photography was born.

Root, Marcus Aurelius. *The Camera and the Pencil*. Pawlet, Vermont: Helios, 1970. (Originally published in 1864.)

Rosenberg, Harold, "A Meditation on Likeness," preface to Richard Avedon's *Portraits*. New York: Farrar, Straus and Giroux, 1976.

Rudisill, Richard. *Mirror Image: The Influence of the Daguerreotype on American Society*. Albuquerque: University of New Mexico Press, 1971.

Scharf, Aaron. *Art and Photography*. Baltimore: Penguin Books, 1975. (Revised edition. Originally published in 1968.)

Schwarz, Heinrich. *David Octavius Hill*. New York: Viking Press, 1931. A critical biography of the early photographer which contains many valuable ideas about the interpretation of images.

Snelling, Henry. *The History and Practice of Photography*. New York: Morgan and Morgan, 1970. (Originally published in 1849.) Snelling's remarks deal exclusively with formal studio photography.

SELECTED BIBLIOGRAPHY
====

Sontag, Susan. *On Photography.* New York: Farrar, Straus and Giroux, 1977.

Szarkowski, John. *The Photographer's Eye.* New York: Museum of Modern Art (distributed by Doubleday), 1966.

SOCIAL AND CULTURAL HISTORY

Aries, Philippe. *Centuries of Childhood.* Translated by Robert Baldick. New York: Vintage Books, 1962.

Dobroszycki, Lucjan, and Barbara Kirshenblatt-Gimblett. *Image Before My Eyes.* New York: Schocken Books, 1977.

Dyos, H. J., and Michael Wolff. *The Victorian City: Images and Realities.* Two volumes. London: Routledge and Kegan Paul, 1973.

Freud, Sigmund. *Civilization and Its Discontents.* Translated by James Strachey. New York: W. D. Norton, 1962.

Goffman, Erving. *The Presentation of Self in Everyday Life.* New York: Doubleday Anchor, 1959.

Lasch, Christopher. *Haven in a Heartless World: The Family Besieged.* New York: Basic Books, 1977.

Marcus, Steven. *The Other Victorians.* New York: Basic Books, 1966. A study of sexual attitudes—and pornography—among the Victorians.

Trevelyan, G. M. *English Social History.* Third edition. London: Longmans, Green and Company, 1946.

Zaretsky, Eli. *Capitalism, The Family, and Personal Life.* New York: Harper Colophon Books, 1976.

PHOTOGRAPHIC HISTORIES OF PARTICULAR FAMILIES
AND GROUPS

Barthes, Roland. *Barthes.* Paris: Écrivains de toujours, 1975.
Barthes's autobiography contains numerous family photo-
graphs upon which he comments at varying lengths.

Gallagher, Dorothy. *Hannah's Daughters: Six Generations of an
American Family 1876-1976.* New York: Thomas Y. Crowell,
1976.

Gernsheim, Helmut, and Alison Gernsheim. *Victoria R.* New
York: G. P. Putnam's Sons, 1959.

Gordon, Colin. *A Richer Dust: Echoes from an Edwardian Al-
bum.* New York: J. B. Lippincott, 1978. Gordon reconstructs
a family's life from some 600 photographs he happened to
find.

Jury, Mark, and Dan Jury. *Gramp.* New York: Grossman, 1976.

Kübler-Ross, Elizabeth (text), and Mal Warshaw (photographs).
To Live Until We Say Goodbye. Englewood Cliffs, N.J.:
Prentice-Hall, 1978.

Lange, Dorothea, and Margaretta K. Mitchell. *To a Cabin.* New
York: Grossman, 1973. A collection of photographic studies
taken by Lange of her grandchildren at a cabin near the sea.

Noren, Catherine Hanf. *The Camera of My Family.* New York:
Knopf, 1976.

Norfleet, Barbara. *Wedding.* New York: Simon and Schuster,
1979.

Talbot, George. *At Home: Domestic Life in the Post-Centennial
Era, 1876-1920.* Madison, Wisc.: The State of Wisconsin His-
torical Society, 1976.

Thomas, Alan. *Time in a Frame: Photography and the Nine-
teenth-Century Mind.* New York: Schocken Books, 1977.